Photoshop
IN A WEEKEND

Photoshop

IN A WEEKEND

photographers'
pip
institute press

Mark Cleghorn

First published in 2008 by Photographers' Institute Press
an imprint of The Guild of Master Craftsman Publications Ltd
166 High Street, Lewes, East Sussex BN7 1XU

Text and photography © Mark Cleghorn 2008
© Copyright in the Work, Photographers' Institute Press 2008

ISBN 978-1-86108-557-3

A catalogue record of this book is available from
the British Library.

Associate Publisher **Jonathan Bailey**
Production Manager **Jim Bulley**
Managing Editor **Gerrie Purcell**
Editor **Tom Mugridge**
Managing Art Editor **Gilda Pacitti**
Design **JoPatterson.com**

Colour origination **GMC Reprographics**
Printed and bound in China by **Sino Publishing**

Contents

6 INTRODUCTION

7 HOW TO USE THIS BOOK

8 **1 Getting Started**

54 **2 Basic Corrections**

82 **3 Advanced Corrections**

118 **4 Projects**

152 **5 Output**

170 GLOSSARY

173 USEFUL WEBSITES

174 INDEX

INTRODUCTION

Welcome to *Photoshop in a Weekend*. This book is designed as a visual reference and quick-start guide for working with Adobe Photoshop CS3.

Photoshop is an immense program and can be quite daunting at first, so this book strips it down to the key skills that you need to start working straight away. This way you will learn a simple and very productive system for working with images, enabling you to become more creative more quickly – in one weekend, in fact! You will soon master the basic Photoshop skills photographers use every day, and discover time-saving techniques that will help you create fantastic images every time.

This book is presented in such a way that you can start at the beginning or jump straight to the section you want. However, if you're completely new to Photoshop, you should start at the beginning and work your way through to the end, as the book is carefully sequenced to familiarize you with the essential features and functions first, before moving on to more advanced techniques. But if you're a more experienced user, you can pick and choose the particular topic you want to learn each time you sit down at the computer with the book. There's a Summary and Checklist at the end of each chapter so you can check you haven't missed anything out.

Many Photoshop menu commands have a keyboard shortcut, as with most software, but instead of trying to master them all at once, the most relevant ones are highlighted during each technique. It's like learning a new language a few words at a time. If you decide to follow this book over several days or weeks instead of in a single weekend, it's a good idea to refresh yourself on the basics each time – this may slow you down a little initially, but in the long run it's time well spent.

Good luck, have fun, and remember to take a short break from the computer every 45 minutes or so to rest your eyes and help you digest all this new information.

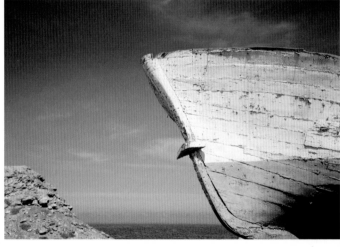

If you're serious about photography, Photoshop CS3 has everything you need to create great-looking, professional-quality images every time.

HOW TO USE THIS BOOK

Photoshop in a Weekend has been designed to make it as easy as possible to absorb all the information you need to get started quickly with Adobe Photoshop CS3.

Take a look at the annotated pages below to familiarize yourself with the key elements of the book. Throughout *Photoshop in a Weekend*, keyboard shortcuts are given in the format Shift+Ctrl/Cmd+X. This means that you need to hold down the Shift key on your keyboard at the same time as the Ctrl key (or Cmd key if you're using a Mac) and then press X. You will also be asked to Alt+click or

Shift+click – this means holding down the Alt or Shift key and clicking the right-hand button on your mouse. Menu commands are given in the format *Edit > Select All*. The first term in a menu command refers to the corresponding item in the main menu at the top of your screen (in this case, the *Edit* menu); subsequent terms refer to items that appear under this initial menu when you click on it.

Introductory text tells you exactly why you need to learn each process.

Keyboard shortcuts. Don't try to learn them all at once – only the essential shortcuts for each task.

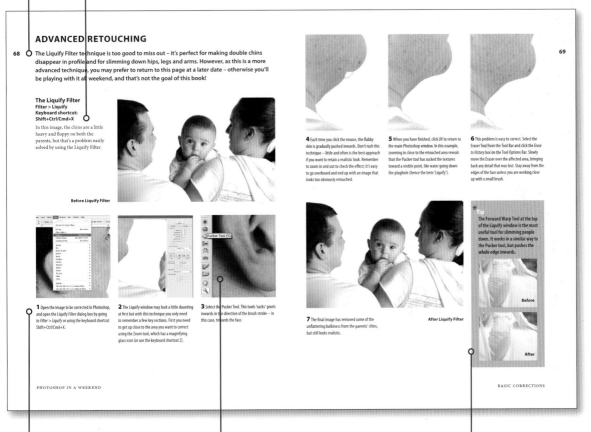

Easy-to-follow step-by-step instructions guide you through each project or technique.

Screengrabs show you exactly where to find each command on screen.

Tips – time-saving hints from a seasoned professional.

Getting Started

In this chapter, you will learn the skills that you need to set up and understand the basics of Photoshop CS3, as well as customizing your screen layout for maximum efficiency and getting to grips with the drop-down menus and Tool Bars. We will also introduce the concept of 'workflow' – the easiest and most organized way to manage your images, from capture to output.

■ A BRIEF HISTORY OF PHOTOSHOP

■ THE PHOTOSHOP FAMILY

■ COMPONENTS OF ADOBE PHOTOSHOP CS3

■ ADOBE CAMERA RAW

■ SAVE FOR WEB & DEVICES AND DEVICE CENTRAL

■ CALIBRATING YOUR SYSTEM

■ COLOUR MANAGEMENT

■ INTRODUCTION TO PHOTOSHOP TOOLS

■ MENUS

■ WORKSPACES

■ RULERS AND GUIDES

■ FILE FORMATS

■ BRIDGE

■ USING BRIDGE

■ ADOBE CAMERA RAW – BASIC 1

■ ADOBE CAMERA RAW – BASIC 2

■ ADOBE CAMERA RAW – ADVANCED 1

■ ADOBE CAMERA RAW – ADVANCED 2

■ SUMMARY & CHECKLISTS

A BRIEF HISTORY OF PHOTOSHOP

Adobe Photoshop is the market-leading software package for digital photographers. The first version was released in 1990 and it has been updated and improved regularly ever since. This book is based on Photoshop CS3, the most powerful and advanced version yet.

If you're completely new to Photoshop and have just bought Photoshop CS3, *Photoshop in a Weekend* will show you all the basics, and using the program will soon become almost second nature. Equally, if you have used earlier versions of Photoshop and need to get up to speed quickly on the new functions available to digital photographers in CS3, you've come to the right place. A brief history lesson will show you why CS3 is such a great package, and how it's become a one-stop solution for digital photographers.

Some of the techniques covered in this book utilize basic features that have been present in every version of the program from Photoshop 6 upwards; a few can even be traced back to Photoshop 4. For me, Photoshop really came alive in Photoshop 7, by which time everything seemed to work for the photographer more quickly and

more creatively. Then came Photoshop CS (Photoshop 8) and what seemed like a step backwards for the photographer, as every procedure seemed to become sluggish compared to Photoshop 7 – but that was a long time ago, so let's not dwell on wasted money.

The program took a major step forward with version CS2 (Photoshop 9) and the introduction of Bridge, a replacement for the basic file browser, which in earlier versions had been visible on the actual Photoshop desktop (see page 15 for more about Bridge). Bridge made viewing and organizing multiple images far more intuitive, and far more convenient than opening each image individually in Photoshop itself. For me, it made other software – such as Kodak Photodesk and Canon DPP – redundant, because I could also use Bridge to edit and process my RAW camera files. RAW is the image format of choice for most

Apart from a few cosmetic changes, the Photoshop CS2 interface hadn't changed all that much since the earliest versions of the program.

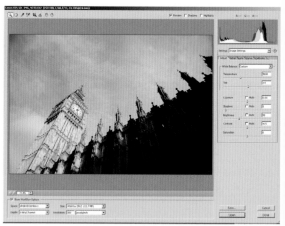

Camera RAW really came of age in Photoshop CS2, processing RAW files more quickly and making Bridge and Adobe Camera RAW the default editing and processing software for many photographers.

professional photographers, and we'll learn more about its advantages on page 16. Bridge has become not only my editing and sorting window, but also the place from which I launch Adobe's Camera RAW processor, which is used to process bulky RAW files into more manageable JPEGs or TIFFs.

Photoshop CS3 represents the next phase in Photoshop's evolution, with even better file-processing capabilities and advanced editing features for greater creativity – not forgetting the speed at which it can apply complex effects – a far cry from applying a filter to an image in Photoshop 3 and going to make a cup of tea while it did its job! If you're familiar with Photoshop CS2, you may be concerned about the new-look desktop – but don't be scared, you will soon adapt to the new features and start to enjoy the extra screen space that CS3 offers.

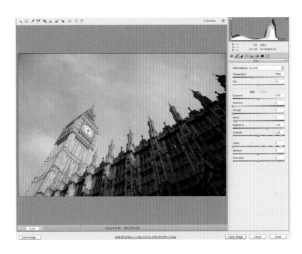

In Photoshop CS3, Camera RAW offers many more RAW processing options than earlier versions, and allows you to adjust JPEG and TIFF files in a similar way.

Photoshop CS3 windows now look very different in comparison to earlier versions – especially the main Photoshop window, as the palettes are designed to expand and collapse, not just be switched on and off. This helps to prevent the desktop clutter that was a feature of working with earlier versions of the program.

THE PHOTOSHOP FAMILY

PHOTOSHOP ELEMENTS

Adobe Photoshop Elements is a scaled-down version of the full Photoshop package and costs a fraction of the price, but because it doesn't include many of Photoshop's more advanced, professional-level features, it is more suitable for the domestic user than the serious photographer. The most recent version is Photoshop Elements 6, and you can download a free trial version from www.adobe.com.

Just like the full version of Photoshop, Photoshop Elements allows you to manipulate, edit and enhance images, with the ability to select and adjust specific areas of a photograph, making image-manipulation light work compared to most other photo-editing software.

Elements includes an integrated step-by-step guide for many of the most common photo-editing tasks, so you can simply select the procedure you want to perform from the menu and follow the instructions given on screen. This is great for amateurs or casual users, but can become a little irritating, or at least unnecessary, if you're using it regularly for serious photographic work. But it's great for quick design layouts, scrapbook layouts and cards, and you can even design a whole book on screen and have it delivered to your door using an online service.

Photoshop Elements 6 also includes an organizer similar to Photoshop's Bridge, which makes it easy to add labels and tags to images, enabling them to be easily located at a later date. Photo retouching and visual tricks such as swapping faces became even easier in version 6, as it includes functions such as merging and auto-aligning layers similar to those in Photoshop CS3.

Features such as simple slideshows and web pages are also included in Elements, making it very easy to share and show your images with friends and family.

Photoshop Elements 6

> * **Tip**
>
> If you are on a budget, Elements 6 is a great starting point. But if you are serious about photography, you will soon require the more advanced image-editing and creative features that are only available in the full version of Photoshop.

LIGHTROOM

Adobe Photoshop Lightroom is, in many ways, the perfect complement to Photoshop, making it even easier to edit, sort and adjust a large volume of digital photographs. But if your budget is tight, don't buy it right away because Photoshop can perform many of the same tasks, at least when you're first starting out as a serious photographer.

Lightroom is marketed as 'the professional photographer's essential toolbox', and the key word here is 'professional'. The program certainly does have some advantages over Photoshop's built-in capabilities, but these are very much geared towards managing large image libraries and finding, adjusting and outputting images for a range of clients or other purposes.

Lightroom features a range of tools for globally adjusting large numbers of images – including white balance for correcting colour casts and exposure compensation to recover any lost detail in shadows and highlights.

The main points of interest for me are the advanced metadata support, making it easier to add detailed information to an image – for use in photo libraries, for example – and the non-destructive editing capabilities. Non-destructive editing allows you to make multiple adjustments to an image without ever losing any of the original image data. Also, the web gallery builder in Lightroom is far superior to Photoshop's own version, allowing you more control over the design and appearance of your web pages.

Adobe Photoshop Lightroom

*****Tip**
Lightroom is a powerful image-management tool, but save your money unless you're planning to go into business as a photography professional or have a vast archive of photographs to process.

COMPONENTS OF ADOBE PHOTOSHOP CS3

Photoshop is not just a daylight darkroom for image manipulation and correction; it is a one-stop shop for the creative digital photographer. Here, we will introduce you to the four main areas of the program that you will be using throughout this book.

There are four main sections to Photoshop, each designed to assist photographers – as well as graphic designers, illustrators and digital artists – to achieve stunning results quickly and efficiently. The various parts of the Photoshop package are integrated for ease of use, and many of its operations can be automated using Actions (see pages 134–7). These allow mundane tasks to be applied to a group or folder of images with little or no additional input from the user.

Photoshop

Photoshop itself is the main focus of the software bundle, and is used for manipulating, correcting and enhancing images. This is what you pay your hard-earned money for – and it's worth every penny! Photoshop can handle everything from simple corrections to an image, such as cropping and colour adjustment, to radical enhancements and effects that are limited only by your imagination.

Layers are the key to Photoshop's power. Layers enable different parts of an image, or other images entirely, to be stacked on top of each other and altered independently.

You can also change the way in which layers interact with each other, using powerful features such as opacity and blending modes, giving you an astonishing degree of flexibility when manipulating your photographs. Mastering the use of layers will enable you to create images you never before thought possible (see pages 84–9 for more information on using layers).

Photoshop Actions can be created and tailored to suit your own individual way of working, and make it a breeze to perform simple but repetitive tasks – such as cropping, resizing or adding a copyright symbol to multiple images – in a matter of seconds. This powerful tool is invaluable to all digital photographers and will save you a lot of time, whether you're an enthusiastic amateur or a professional at the top of your game.

Web galleries are also easy to create using a folder of images and one of Photoshop's simple, pre-designed templates. The fully automated website builder even adjusts the images to the size required, making it very light work to build your own sites (see pages 158–61).

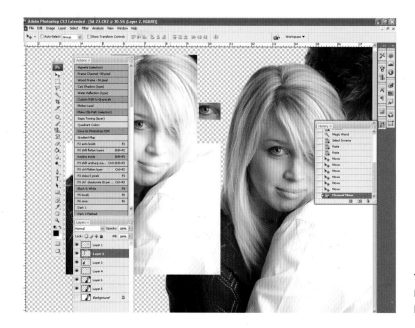

The Photoshop workspace. Note the Layers and Actions palettes on the left of the screen.

Bridge

Bridge is primarily used for organizing images. Multiple viewing windows allow images to be dragged and dropped or copied to other folders. Images can be stacked on top of each other, saving space on your desktop and allowing you to view the most important images at a larger size.

In Bridge, you can quickly add information to your image files in the form of metadata. Metadata can be as simple as the name and date of a shoot, or it can include a full list of terms for future searches, making it easy to find a specific image even if you've long since filed it away and forgotten about it. The visual labelling of images with colours and star ratings is an invaluable visual editing system, and you can select different groups of images by label or by a combination of different labels.

Simple sliders allow images to be viewed at different sizes when in the contact sheet viewing mode, and the loupe, or magnifier, enables you to examine details of an image at 100% magnification to check its focus or simply to take a closer look at a subject's facial expression. Images can also be viewed as a slideshow, with a variety of transition effects available as well as a zoom facility. You can even apply visual labels or stars for future reference while you're watching the slideshow.

Bridge is also the basic platform from which to launch Camera RAW (see page 16), a powerful post-production processing module within Photoshop for RAW files – and, in Photoshop CS3, for JPEG adjustment as well (see pages 36–43 for more information on using Bridge).

***Tip**
You may be desperate to load up some images and get started, but spend a little time familiarizing yourself with the basic structure of the Photoshop package first. It'll save time in the long run.

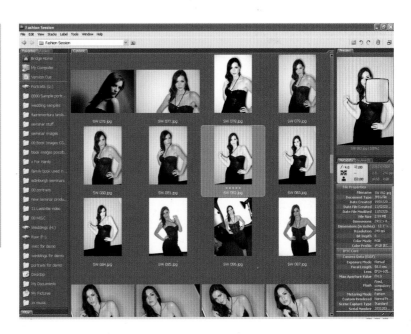

Bridge enables photographers to evaluate, edit and organize a whole shoot quickly and easily.

ADOBE CAMERA RAW

Adobe Camera RAW is the first point of correction and manipulation for most professional photographers, who use this part of the Photoshop bundle to process the RAW files they capture on camera. Camera RAW can correct colour, exposure, contrast and tone in large numbers of images at the same time, making it the photographer's best friend.

Camera RAW allows both RAW and JPEG files to be adjusted, but it's important to remember that only RAW files are edited non-destructively – which means that whatever adjustments are made to the file, the original image data is retained and the file is still fully editable next time you open it. A JPEG file, on the other hand, will be overwritten and the adjustments applied permanently and irreversibly to the file if it is opened in Photoshop and saved with the same file name.

Some photographic corrections, such as the removal of red-eye and dust spots, can be applied to multiple images simultaneously in the Camera RAW software. This can be very useful indeed – imagine discovering dust on your CCD and having to perform the same corrections individually to every image from a shoot. CS3 also introduced advanced black-and-white adjustments in Camera RAW, as well as simple but effective split toning, a process once confined to the darkroom.

Any adjustments in Camera RAW can be saved as specific 'looks', to once again assist with the automation of batches of images. This function can either be applied in the Camera RAW window or, for even more efficiency, directly from the Bridge window (see page 15 for more on Bridge).

In Adobe Camera RAW, you can correct your images before processing them in Photoshop (top). With CS3, you can also retouch and split-tone the RAW image without discarding the original image data (below).

Stepping backwards is a luxury you can afford with Camera RAW, because any adjustments you make are 'remembered' in the original file.

SAVE FOR WEB & DEVICES AND DEVICE CENTRAL

With many digital photographs now destined for display on the internet or any one of numerous mobile devices, rather than as a print, it's important to optimize your images correctly for digital display. This is easier than ever in Photoshop CS3.

Prior to CS3, a function called Image Ready was used to prepare images for the web. The software was launched from either Photoshop or Bridge and could adjust an image or group of images to the best possible quality for the web with the smallest file size.

This software is now integrated within CS3 as the new Save for Web & Devices feature in Photoshop, and Device Central has replaced Image Ready. It works in much the same way, however, with functions that convert images to the optimum size and resolution not only for the web, but also for portable devices such as mobile phones or iPods. It's remarkably easy to use, as a preview screen displays your image as it would appear in the chosen device.

Animated GIF files can also be prepared from a layered image in Photoshop to create simple but effective moving images. The layers are blended into each other and automatically prepared for the web or a device.

In the Save For Web & Devices dialog box, you have the option to set the target size and image quality. Check the file size at the bottom of the window: the smaller the file, the quicker it will be rendered on screen.

Simple but effective animations for the web can be created in the form of a GIF file. This is done by creating a multi-layered file in Photoshop (left) and then applying the transition effects in the Save For Web & Devices dialog box (right).

CALIBRATING YOUR SYSTEM

Colour can be a really big headache. In the past, when we shot on film, good photo labs usually fixed any colour quirks by adjusting the cast, so the photographer never really had to deal with them. Now that the darkroom is on your desktop, it's up to you to fix the problem – and prevention is definitely better than cure.

Accurate colour calibration throughout the process from camera to print is essential to make the digital journey easy, so let's start at the beginning. Colour should always be balanced against a neutral grey – not white or black, because colour can be hidden within these tones. An 18% grey is also used to determine exposure, so that highlights contain information in the white areas and shadows retain detail in the blacks.

Camera

If you're shooting JPEG files, your camera should be set to the desired colour settings before you take any exposures, as the setup will drastically affect the image as captured and therefore any post-production you wish to carry out. If you shoot in RAW format, settings such as white balance are held separately from the image itself and can be adjusted later with no reduction in image quality. (See pages 34-35 for more on file formats.)

In the days of film, different manufacturers produced film with different colour intensities: Kodak was renowned for a more neutral contrast and a cooler, more accurate colour than, say, Fuji film, which was known for increased contrast and more saturated colours. Some digital cameras have settings to emulate these film types – my Canon 5D camera has a variety of different 'looks' that come supplied as standard, with everything from a neutral colour setting to a more saturated setup, as well as one for black and white. However, these looks are only applied to an image shot as a JPEG file. These preset looks can also be applied to a RAW file, but only when the file is processed from RAW to a JPEG or a TIFF file using the camera manufacturer's own software.

No matter what file format you shoot, the main factor determining the colour balance of your shots is the colour setting you choose on your camera. These usually include Automatic, Daylight, Flash, Cloudy, Tungsten, Fluorescent and a custom balance setting. Let's look at these settings in a little more detail.

AUTOMATIC is often best avoided. This setting analyzes the scene and tries to produce a neutral image, but any strong colours present in a scene – such as a bright red door or green grass – can fool the process and produce an unnatural-looking result. It will also adjust the colour of almost every image as you zoom in and out, so there may be more work to do in post production to match one image's colour tone to the next.

FLASH is my preferred camera setting. This sets the colour balance to a slightly warmer tone to allow for a slight blue colour cast from a flash. I shoot in the RAW file format so any colour cast due to the location or weather can be adjusted in Adobe Camera RAW, but because all the images will have the same cast, any or all of the files can be adjusted simultaneously instead of one at a time. The Flash setting is based on a neutral grey.

CUSTOM BALANCE is the best setting to use if you have plenty of time. This involves taking a shot in situ, usually of a grey card or a Lastolite Ezybalance reflector. The colours in the resulting image are analyzed by the camera, which adjusts for any colour cast on the grey card and produces the setting accordingly. Another useful product is an ExpoDisc, which fits onto the front of the lens and works in a similar way, analyzing colour through a filter.

DAYLIGHT mode sets the white point for midday under bright, sunny conditions.

SHADE increases the warmth of the image to compensate for an expected blue cast.

CLOUDY increases the warmth even more to compensate for a greater degree of shade.

TUNGSTEN increases the blue in the image to compensate for the expected yellow/orange cast.

FLUORESCENT increases the blue, as well as a slight magenta, to compensate for fluorescent light conditions.

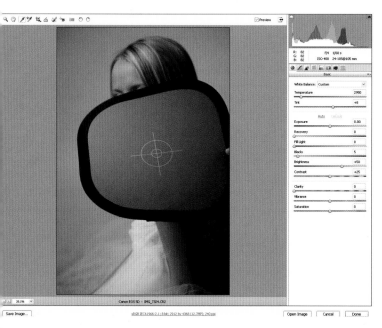

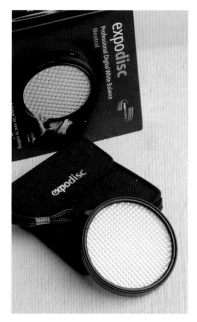

The Lastolite Ezybalance is a neat grey-balance reflector that fits into any camera bag, and is designed for heavy usage. The grey-balance reflector is used to calibrate the camera using the Custom Balance setting while on location, or to click-balance an image in post-production.

An ExpoDisc fits onto the front of your camera's lens and is used to set the Custom colour balance. It averages out the colour in a scene, giving a more accurate rendition than the camera's Auto setting.

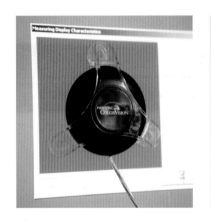

Monitor

When you view your image on screen and it appears to have a slight colour cast, it may not be the actual image that is at fault. Often, the problem stems from an uncalibrated monitor. Colour calibrating your monitor is essential to ensure accurate results when working with images. To calibrate your monitor, you can use the calibration function included in Photoshop, but this depends on the accuracy of your own eyesight and will never be as reliable as a dedicated screen calibrator. It is worth investing in a calibrator, which is dangled in front of an LCD monitor or suctioned onto the screen of a CRT monitor. The calibrator analyzes the colour levels that the monitor can display and brings them within a standard range, which is again based on a neutral grey, to give you a far superior print.

Calibrating your monitor only takes a few minutes. A CRT monitor should be calibrated at least every two weeks, while an LCD monitor should only need calibrating monthly. Avoid calibrating or adjusting an image on an LCD monitor straight after switching it on, as the LCD needs time to come to life fully; screensavers also interrupt the power to the screen, so when you return to an LCD monitor after a break, make sure the LCD is fully awake before adjusting an image.

This calibrator is called a Spyder. Its software displays various different colours on screen and the calibrator measures your monitor's output to construct an accurate colour profile.

Printer

Calibration is based on analyzing the colour the monitor can output to the printer. A monitor uses red, green and blue (RGB) to construct an image, while a colour print from an inkjet printer is made by mixing cyan, magenta, yellow and black (key) inks (CMYK) – so a translation needs to be made between screen and print. Standard colour settings (known as ICC profiles) and a calibrated system help to cure any translation problems between screen and print, so take time to set up your system and install the correct profiles for the printer and paper you are using – investing in a monitor and printer calibrator is not enough, as a simple change of paper can change the whole look. The printer will print a file, which is then analyzed by the calibrator to set a new printer profile for far more accurate prints on that particular paper stock.

> **✳ Tip**
> To get the best results from your printer, you need to set up its colour profiles. This will ensure that what you see is what you get when you print your images. See page 162 for more information on profiles and printing.

COLOUR MANAGEMENT

Accurate colour is made possible by the use of ICC profiles such as sRGB and Adobe RGB.
These profiles are tagged into the image at capture or in RAW processing, as well as in
photo-editing software such as Photoshop. The colour is captured not only in the colour
channels themselves, but also in the brightness, hue and saturation.

Camera

The first thing to set on the camera is the colour space
in which the image will be recorded – either sRGB or
Adobe RGB. These two different colour spaces will give
the colours a slightly different saturation when printed.
The sRGB colour space has become the most common
for the photographer outputting to either a photo lab or
to an inkjet printer, because it is widely compatible with
cameras and computer hardware. Adobe RGB (1998) is
the colour space of choice for the photographer who is
likely to have images printed in a magazine or book, and
is considered to be the most stable. Refer to your camera
manual for guidance on how to set its colour space.

Photoshop

When you open Photoshop for the first time, and before
you start working on any images, you will need to set the
Color Settings options. From the menu, go to *Edit > Color
Settings...* and choose from the following options:

sRGB For general use, especially for printing on an inkjet
printer or sending images for printing at a photo lab.

Adobe RGB (1998) The most stable of all colour spaces
and widely used by photographers whose images are
destined for professional printing or photo libraries.

CMYK The standard colour space used by the printing
industry. Don't use CMYK for working on images on
your computer, as the colours are based on the mixture of
inks used to output files onto white paper.

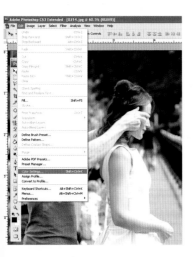

Go to *Edit > Color Settings...* in
Photoshop to choose your preferred
colour space.

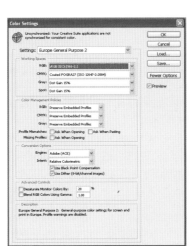

Select your colour space based
on your output. Ensure *Color
Management Policies* is set to
Preserve Embedded Profiles.

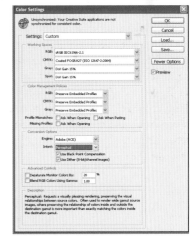

In the *Conversion Options* box, set
Engine to *Adobe (ACE).* If most of your
pictures are of people, change the
Intent to *Perceptual,* as this gives a
smoother transition to colour tones.

INTRODUCTION TO PHOTOSHOP TOOLS

Getting to grips with Photoshop's tools is not as daunting as you may think, and if you are starting off with Photoshop CS3, you won't have to worry about the dramatic change to the desktop layout from previous versions. Some of the tools are intended for more advanced editing and are therefore beyond the scope of this book. To help you get started quickly and with the minimum of fuss, we will only examine the essentials – but Photoshop being Photoshop, even the basics are enough to get fantastic results!

Tool Bar

All of Photoshop's tools are located in the Tool Bar on the left-hand side of the screen. You will notice a small triangle in the bottom right-hand corner of each tool icon; left-click and hold down the mouse button to select the related tools. There are keyboard shortcuts to all of these tools – just press the appropriate key and the tool will be automatically selected. These shortcuts will be used throughout the the book so you can start to memorize them. This will save you a lot of time in the long run.

The Tool Bar is split up into sections, as you will see by the dividing lines around some of the tools.

At the top of the Tool Bar are the basic Selection tools. These are used to isolate specific parts of the image, and include the Crop tool (shortcut C) for cropping images, and the Move tool (V) for moving parts of an image once they are selected.

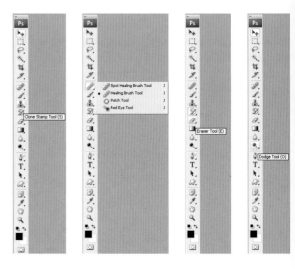

The Clone Stamp, Healing Brush, Eraser and Dodge and Burn tools.

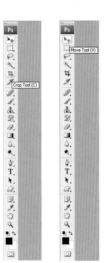

The Crop tool and the Move tool on the Photoshop Tool Bar.

✱ Tip

When you hover your cursor over a tool, a pop-up note will appear showing the tool name and the keyboard shortcut for that tool.

The next section down contains the Editing tools. These are used for retouching and image enhancement, and you will be using them frequently during the course of this book – especially the Clone Stamp tool (S), Healing Brush (J), Eraser (E) and Dodge and Burn tools (O).

From the next section down, we will only be using the Type tool (T), so we can ignore the other tools for the purposes of this book.

The final section of tools includes the basic Eyedropper (I) for selecting a colour; the Zoom tool (Z) for closing in on a particular area of an image (or zooming out when the Alt key is held down while the Zoom tool is selected); and the Hand tool (H) for moving the visible are of the image around the screen.

At the bottom of the Tool Bar is a pair of black and white squares. These squares represent the Foreground and Background colours, which can be changed by selecting the Eyedropper tool (I) and either picking a colour from the active image or from Photoshop's Color Picker. If the square on top has been changed from its default black to, say, red, red will now appear as the Foreground colour and will be used for painting as well as any text you choose to add to your image.

The Foreground and Background colours can be swapped around by clicking on the little double-ended arrow icon, and reset to the default black and white by clicking on the small black and white squares icon.

The Horizontal Type tool. Holding down the mouse button on this tool also reveals the Vertical Type tool, the Horizontal Type Mask Tool and the Vertical Type Mask Tool.

The Set Foreground Color and Set Background Color icons, and the Switch Foreground to Background arrow.

The Eyedropper, Zoom and Hand tools.

✳ Tip
Double-clicking the Zoom tool will make the active image appear on screen at 100% magnification. Double-clicking the Hand tool will adjust the size of the image so that the entire image fits on your screen.

Tool Options Bar

The Tool Options Bar runs horizontally across the top of the screen, directly under the main menu. It gives you a variety of options for modifying the behaviour of the tool that is currently selected. This gives each tool a lot more flexibility and versatility – for example, enabling you to set the Tolerance or Feather when making selections, specifying a target size and DPI when using the Crop tool, or setting the type style and size when using the Type tool. Also on the Tool Options Bar is a quick-launch button for the selected tool's own options panel, an icon to launch Bridge, and a drop-down menu that allows you to alter your Photoshop workspace.

The Tool Options Bar changes according to which tool is selected from the Tool Bar. With a Brush tool selected, as here, a slider is used to adjust the Opacity of the Brush.

Tool Palettes

On the right-hand side of the screen are the Tool Palettes (sometimes referred to as panels), where you will find many of the functions that give Photoshop its immense power and flexibility. In Photoshop CS3, the palettes have become far easier to use and make more efficient use of space; each of the palettes can be switched on or off or dragged from its original location to anywhere on the screen – even off the Photoshop desktop.

Photoshop incorporates a vast array of palettes, but in the interests of getting to know the program quickly, this book will concentrate on the palettes shown below.

ACTIONS
An Action is an automated series of adjustments that can be applied to one image at a time, or to a whole folder of images, making light work of tedious tasks.

HISTORY
Records all the adjustments you make to an image and allows you to step back to previous stages.

LAYERS

Layers are the power behind Photoshop, enabling you to build up an image by adding or manipulating sections independently, and blending them together in a variety of ways. Keep the Layers palette visible at all times.

CHANNELS

The Channels palette allows you to adjust each range of colours in an image individually using the Red, Green and Blue channels.

NAVIGATOR

This palette is useful in the early stages of learning Photoshop or when you are working close up on a zoomed-in image, as it allows you to move around the image quickly, as well as zoom in and out using a slider.

HISTOGRAM

This palette displays a graph of the spread of pixel tones in an image. The left-hand side of the graph represents the shadow/black areas and the right-hand side represents the highlight/white areas.

BRUSHES

A wide range of preset Brushes are offered in Photoshop, ranging from a very small soft brush to a very large hard brush. Each brush can be adjusted to your own specifications and saved for future use. The options in this palette also apply to the Eraser, Clone Stamp, Art History Brush, Smudge, and Dodge and Burn tools.

SWATCHES

Use this palette to select from a range of predefined colours, or add your own custom colours.

MENUS

The main menu at the top of the screen is where you will find all of Photoshop's basic commands, and just like the Tool Bar they are organized in a logical order to help you find the command you need. Let's look at each drop-down menu in turn to help you familiarize yourself with the essential functions.

File

Photoshop's File menu is quite similar to the File menu in most other programs, with commands to Open, Close and Save your files, plus Page Setup and Print. You can also choose Browse, which will open Bridge and allow you to choose images to work with from any folder on your computer. There are also some automation functions listed at the bottom of the menu.

Edit

The Edit menu contains familiar commands such as Cut, Copy and Paste, which work in a similar way in many other applications. The Check Spelling and Find and Replace Text commands also work just like those in a word processor (but obviously only when you've added text to your image). Using this menu you can also make many more advanced changes to an image, rotating or flipping it with the Transform sub-menu, adding Fill and Stroke colours and defining the behaviour of Photoshop's brushes. This menu is also where the Color Settings and Photoshop Preferences hide (if you are using a Mac, you will find the Preferences under the Photoshop menu on the far left).

Image

The Image menu is crucial, particularly the Adjustments sub-menu, as this is where you can make numerous creative alterations to an image. There are Brightness and Contrast controls, which will probably be familiar from your TV set, but also Levels and Curves, which give you far greater and more refined control over the range of tones and colours in your picture. From the Image menu you can also change the size and resolution of your image using the Image Size command, or add extra space around it using the Canvas Size option. You can also change the colour mode, with options including CMYK Color and Grayscale, but for the purposes of this book the mode should remain set to RGB Color.

Layer

As we've already noted, layers are one of Photoshop's most important and useful features, and in this menu you can create new layers or adjustment layers, alter or delete layers you have already created, group layers together, and much more. Some layers – those that include text or other vector-based graphics – need to be rasterized (converted to pixels) before any effects can be applied. Also, unless you are planning to save every image you adjust as a multi-layer document (called a PSD – see pages 34–5 for more on file formats), you will want to apply the Flatten Image command before printing or sharing your files.

Select

The name of this menu speaks for itself: the Select menu is where you go to change or refine any selections you have made on your image.

Filter

Newcomers to Photoshop can easily get carried away with the Filter menu, playing around with the numerous custom effects that come supplied with Photoshop. However, most photographers advise careful and judicious use of filters, and many filters are completely unnecessary for most photographic tasks. So, although filters are lots of fun, if you are trying to learn Photoshop in a weekend, leave them for another time. But don't despair – there are a few filters that we will be using in this book (see pages 100–4).

View

The main function of the View menu is to fit your image onto your screen in the most useful way, and to show and hide Guides and Rulers on the image. Guides and Rulers are powerful tools for everyday use and we will look at them in detail on pages 30–3.

Window

This menu allows you to display any of the Tool palettes by selecting its name from the drop-down list. It's most useful when you have switched off one or more palettes to save space on your screen, or to bring to life any palettes that are not switched on by default. At the bottom, the menu also shows the names of all the files currently open in Photoshop and allows you to switch between them. (If you are using a PC, you can also switch between open files by pressing and holding the Ctrl key and then pressing the Tab key. On a Mac you can do the same using the function keys or the mouse – set your preferred method in the System Preferences.) The Window menu also enables you to set up and save your preferred Workspace – that is, which windows and palettes are open on your screen and where they are located.

Help

Never be afraid of looking at the Help menu, especially in the early days, because there are some very useful 'How to' guides built in. This menu also includes the Updates facility – make sure you check this regularly, as updates can be downloaded to fix any little bugs that Photoshop may have on release, or that are discovered and reported subsequently by users.

WORKSPACES

Workspace is the term used to describe the way your Tool palettes are arranged on the screen. Photoshop sets its own default workspace but this may not be ideal for you. It's important to find a workspace you are happy with, so everything you need is close at hand and you don't waste time continually opening and closing the palettes you use most often.

You can save your own workspace – or workspaces, you can have as many as you like – by going to *Window > Workspace > Save Workspace*. When you save a new workspace it becomes the default until you reset it. However, finding your own ideal workspace comes with time and experience, so to start you off I've devised a workspace that works well for the projects in this book.

First, drag all the palette icons into the main desktop area to make them easier to see. Make sure you have the following palettes on the screen: Layers, Actions, History, Channels, Navigator, Info, Swatches and Tool Presets. If any other palettes are open, close them by clicking on the X icon at the top right of the window.

These are the palettes we will be using most throughout this book, so ensure they are included in your workspace.

When you're familiar with each palette, grab its tag and drag the palette back to the dock on the right-hand side. You can choose where you would like each tool to be located in the column. You will see a small blue line appear if you drag a palette to the bottom of one of the columns; if you drag it between two different palettes, it will be grouped with one of them, depending where you

drop it. I keep the History, Layers and Actions palettes grouped together most of the time because they are the ones I use most often.

You can choose to view the docked palettes as just icons, or, by holding the cursor next to the icon, you can drag the resulting arrow to the left to display the palette names.

Here, the tool palettes are docked and fully collapsed, showing only their icons.

Here, the tool palettes are docked but their names are still visible. You may decide to use this option until you are more familiar with the tool icons.

RULERS AND GUIDES

Rulers and Guides are a great help when laying out images on a page, cropping to a specific size or aligning layers. I keep the Rulers switched on at all times – they run along the top and left-hand side of the image window and track the position of the cursor or tool being used.

Rulers

To open the Rulers, go to *View > Rulers* or use the keyboard shortcut Ctrl/Cmd+R. If the Rulers are visible around the edges of the image, you have set the command correctly – each image you open will now have Rulers.

Image open without Rulers.

The *View > Rulers* command.

Image open with Rulers.

The Ruler Tool

To activate the Ruler Tool, select the ruler icon, which is above the Hand Tool at the bottom of the Tool Bar; by default, it is hidden under the Eyedropper Tool, so click and hold on the small arrow at the corner of the Eyedropper icon and the Ruler Tool will appear in the fly-out menu. Alternatively, use the keyboard shortcut I, or Shift+I to scroll through the different tools.

The Ruler Tool allows you to measure a distance in an image. Guides can be also dragged to these ruler points to help with cropping. The Ruler Tool is also perfect for correcting horizons or verticals in an image – simply draw a line across the image at the correct angle for the horizon or upright and then go to *Image > Rotate Canvas > Arbitrary* from the main menu. The angle you set with the Ruler Tool is automatically entered into the Rotate Canvas dialog box, so all you need to do is click OK and your image will be adjusted accordingly.

Locating the Ruler Tool.

Layer Edges

Go to *View > Show > Layer Edges* – this function draws a line around the edge of the currently selected layer. This can make it much easier to see, especially when you are using duplicate sections of the same image, or if the tonal value or colour is similar; the edges will define the layer.

Image open with the *View > Show > Layer Edges* command activated.

Guides

The Guides are made visible by selecting *View > Show > Guides* from the main menu or using the keyboard shortcut Ctrl/Cmd+;. Vertical or horizontal guide lines can be dragged onto an image by positioning the cursor over the rulers at the edge of the image –no matter which tool is selected, when you click and drag the mouse into the image a blue guide line will become visible. You can drag as many guides onto the image as you like, but if the image becomes clogged with guides during retouching, use the keyboard shortcut again and the guides will be switched off.

Guides can be dragged onto any point in your image to help you line up different layers or image elements.

Smart Guides

Accessible via *View > Show > Smart Guides*, Smart Guides act as an instant edge to an image so that you can see its exact position. When you are using layers, Smart Guides become your best friend, assisting you in lining up a layer as it tries to snap to the other layers.

Grids

To switch on Photoshop's grid, go to *View > Show > Grid* or use the keyboard shortcut Ctrl/Cmd+'. Grids can assist you in composition and layout, particularly when you are starting out with Photoshop and when you are adding text to an image (see pages 122-123). For most general photographic tasks, however, I find Guides far more efficient and easier to manage than Grids.

Photoshop's Grids are particularly useful for graphic design, or when you need to align text elements both horizontally and vertically.

Snap

The Snap To command (*View >
Snap To* or Shift+Ctrl/Cmd+; on the
keyboard) is switched on by default
in Photoshop. It automatically aligns
a layer that is being moved to another
visible layer, or to a Guide that
you have dragged onto the image.
However this can become irritating if
you don't want to align your layer to
another layer, so if you don't want to
use the Snap To facility, switch it off
by going to *View > Snap*.

Change your Snap To options by selecting *View > Snap To* from the main menu
and checking or unchecking the items in the flyout menu.

Extras

The Extras command (*View > Extras*
or Ctrl/Cmd+H on the keyboard) is
a useful one to learn. Pressing the
Ctrl/Cmd+H shortcut disables all
the Grids, Guides, Rulers, and Layer
Edge options at once. Use the same
keyboard shortcut again to switch
them all back on.

When you're working closely on an image, it's useful to be able to switch all the
viewing tools on and off with a single command: Ctrl/Cmd+H.

FILE FORMATS

The number of different file formats available may seem confusing at first, but the key thing to remember is image quality. Some formats are designed to enable you to adjust an image with no loss of information, or picture quality – consequently these formats result in large file sizes. Others – notably JPEG – are intended to produce far smaller files, and compress the information in the image to a greater or lesser extent to achieve it. The downside to this is the loss of clarity and sharpness in an image.

This maximum-quality JPEG image has a file size of 4.8 MB.

The low-quality JPEG version is just 539 KB.

This TIFF image has a file size of 36.4 MB.

RAW

RAW is a generic term for the flexible file format used by camera manufacturers. Most professional photographers choose to shoot in this file format because it is lossless in compression and allows us to recover information in an image during post-production – the RAW file captured or camera prevents the camera from processing the colour information into a JPEG. An unprocessed RAW file has to be converted into a working file for printing – such as a TIFF or JPEG – by using Adobe Camera RAW, which is part of Photoshop (see pages 44-51). You could also use the camera manufacturer's own processing software or a third-party program like Bibble to perform the same task before opening the converted file in Photoshop.

DNG

DNG is an abbreviation of Digital Negative, and is a file format that was created by Adobe to address the need for a universal format that supports all the different camera manufacturers' proprietary RAW formats. The DNG format is primarily used as an archival format for RAW files and retains all of RAW's capacity for detail recovery and colour correction in post-production, as well the ability to store metadata within the file.

TIFF

TIFF stands for Tagged Image File Format, and it is the industry-standard format, especially in the commercial world, because the TIFF format uses a form of lossless compression. This means that the quality does not deteriorate during compression, but it consequently produces a much larger file size than a JPEG. The compression standard known as LZW is available as part of the TIFF format, and can compress the size of your TIFF files slightly without losing detail.

PSD

A PSD (Photoshop Document) file is the default file format in Photoshop, and it allows a multi-layered image to be saved without the need to flatten it (reduce it to a single layer). The PSD file is often referred to as the 'master' file, as you can save and open the file as often as you like without any loss of detail through compression, and without losing the ability to adjust layers.

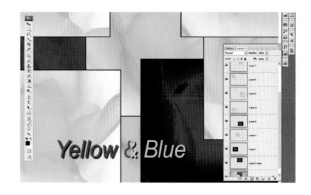

A multi-layered file is best stored in PSD format.

JPEG

JPEG stands for Joint Photographic Experts Group, and this format is the industry standard for compressing continuous-tone images, whether for storage or for the web. JPEG files use 'lossy' compression, which means that every time the image is saved, image data and quality is lost, giving a smaller and smaller file size. The file size will depend on the level of compression you decide to use – when you save the file, you select a compression level ranging from 12 (maximum quality but larger file size) to level 0 (minimum quality but very small file size). The lower the compression number, the more detail is lost. This results in more visible artefacts in the image, which appear as blocky shapes when you zoom in.

This JPEG saved at Maximum quality (12) has a file size of 4.43 MB.

This JPEG saved at High quality (9) has a file size of 1.19 MB.

This JPEG saved at Medium quality (6) has a file size of 478.6 KB.

This JPEG saved at Low quality (2) has a file size of 228.8 KB.

JPEG2000

The JPEG2000 file format supports 16 bits per channel and alpha channels; the format is mainly used for archival purposes, as there are fewer visible artefacts compared to the standard JPEG.

GIF

The Graphics Interchange Format is used for images with a limited number of colours, such as a logo. Due to its small file size, it is popular in web design. The GIF format is rarely used for photographs.

***Tip**

When using multi-layered files in Photoshop, always remember to keep a copy in PSD format before you flatten the image, so you can adjust the individual layers at a later date.

BRIDGE

Image management is a fundamental part of digital photography. Without the expense of film and processing, digital photographers shoot more often and in greater quantities, so it's essential to sort and store your images efficiently. Bridge is a perfect tool for Digital Asset Management (DAM) – that's the technical term for sorting and storing images.

Launching Bridge

Bridge stands apart from the main Photoshop software, so it has its own memory management and options. Bridge can be launched in several ways – from its shortcut icon on the desktop, via the Start menu or from within Photoshop itself. Images can be opened directly into Photoshop via Bridge, or if they are in RAW format, they can be opened in Adobe Camera RAW first (see page 34 for more on file formats, and page 44 for more on Adobe Camera RAW).

Bridge views

The Bridge window can be viewed and customized in many ways. The Default view – number 1 on the list of icons at the bottom right of the window – is a contact-sheet style that displays the images as small thumbnails. When one image is chosen, it is previewed in the window at the top right. In this Preview window, you can click on the image and a loupe (or magnifier) enables you to move around the image and view a section of it at 100% magnification.

View 2 is similar to a filmstrip – in fact it is called Horizontal Filmstrip – and in this mode the selected image is displayed at as large a size as possible in the main viewing window, with the remaining images in the selected folder shown as thumbnails along the bottom. When you click into the main image in the Horizontal Filmstrip view, the loupe reappears to show you the selected portion at 100% magnification.

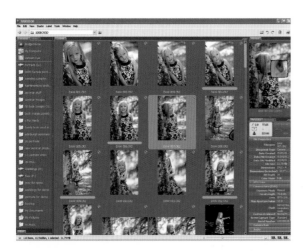

The Default view in Bridge. Note the loupe feature in the Preview window.

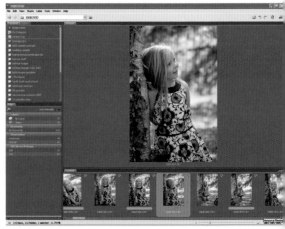

The Horizontal Filmstrip view in Bridge. The Preview window appears in the centre and is much larger.

View 3 is called Metadata Focus and is biased towards the information embedded in the file, called metadata. The window shows small image thumbnails with the file information alongside – details such as date created, date modified, the colour space and image size, and the keywords that have been applied to enable fast and specific searching. Each viewing window can be modified to suit your taste and then stored as a new layout.

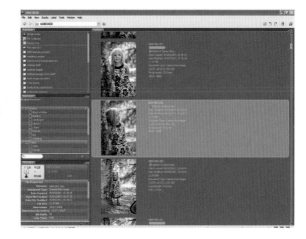

The Metadata Focus view in Bridge displays the information embedded in your images, such as date created, file size and file type.

The Bridge window

It's well worth taking some time to familarize yourself with the location of the most important panels in the Bridge window. The screengrab below shows the window in the Default view, but the basic elements remain the same whichever view you choose, though some may change their size and position.

Favourites
Provides quick access to your favourite folders

Folders
Shows all the folders on your computer

Content
Shows the thumbnail of the selected image or images

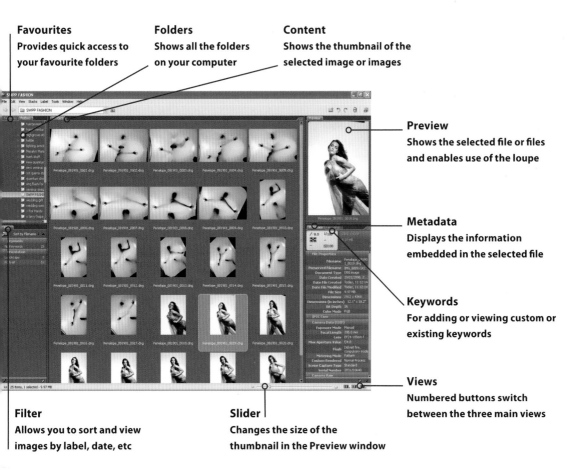

Preview
Shows the selected file or files and enables use of the loupe

Metadata
Displays the information embedded in the selected file

Keywords
For adding or viewing custom or existing keywords

Views
Numbered buttons switch between the three main views

Filter
Allows you to sort and view images by label, date, etc

Slider
Changes the size of the thumbnail in the Preview window

USING BRIDGE

Importing images

Images can be imported from your camera onto your hard drive using Bridge, and you can also select which ones to import and which ones to leave out – essentially, a first edit of your shoot. At the same time, you can rename the images and copy them to a second folder as a backup.

1 Go to *File > Get Photos from Camera* (this option also applies to card readers or other memory devices attached to your computer). Click the *Advanced Dialog* button to see all the images and for more options.

2 If you don't want to import all the images, select the ones you want. Use the *Check All* or *Uncheck All* options at the bottom of the window as a starting point and click the boxes next to the image filenames to select or deselect the required images. Ticked images will be imported; unticked images will not.

3 Select a destination folder for your images by clicking the *Browse* button (the PC default location is the My Pictures folder; the Mac default is the Pictures folder). It's good practice to make a new folder using the shoot date as the reference – for example, 29-07-2008. Think of your images as being stored in a huge library, and choose a filing method that will help you to find them easily in future. For the same reason, you can choose to rename your photos as you import them. To do this, enter your desired name in the *Rename Files* box. You may want to use the location, subject or shoot date in the new name. If you prefer not to rename the files, select *Do not rename files*.

4 Click the *Save Copies to* box, as this will automatically back up the selected images to another drive or folder that you select with the *Browse* button. The photos will be backed up with the original filenames, not the new names given to the files being stored in the new folder. This can cause some confusion later on, but it's a good facility nonetheless.

5 Apply Metadata. This is a good time to add metadata information to the file – usually your name and any copyright information or contact details. You can create your own metadata template in Bridge by going to *Tools > Create Metadata Template*, entering the relevant information and giving the template a name.

6 When you've considered all your options, click *Get Photo* and Bridge will start the importing process.

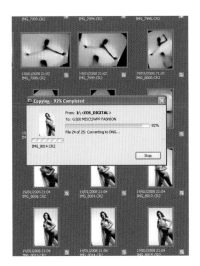

Tips

If you're using a card reader and don't want to import your images using Bridge, you can simply drag your files from your card into a new folder on your hard drive.

As an extra precaution, it's always best to burn a DVD of all your images before editing, renaming or converting them – especially in the early days of using Photoshop.

Sorting and labelling

With the images now stored on your computer, it's time to refine your selection of images – as the saying goes, 'less is more'. Bridge has excellent facilities for this, especially the labelling and star ratings. Star ratings from 1-5 can be applied to an image or a group of images by pressing the relevant number on the keyboard while the image is selected, or by dragging the mouse over the five dots below the thumbnail.

To add a coloured label, press the numeric keys 6-9. Pressing the number again will remove the coloured label.

6= Red **7= Yellow**
8= Green **9= Blue**

When you have finished adding labels or star ratings to your images, you can select all the images with a particular label by clicking on the

label's name in the Labels section of the Filter panel. The images without that label will be hidden. You can select or deselect multiple labels just by clicking on the label name.

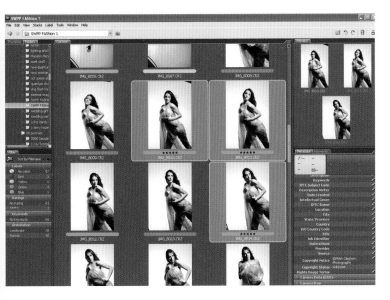

Tip

If stars or coloured labels don't appear when you press the numeric 1–9 keys, go to the Bridge Preferences in *Edit > Preferences* (or *Bridge > Preferences* on a Mac) and choose Labels from the menu. Uncheck the *Require Ctrl key to Apply Labels and Ratings* box at the top of the window. In the same window you can also assign descriptions to the coloured labels.

Slideshow mode

A slideshow is not just a great way to view your images; in Bridge, it's also an excellent way to edit them. The method described here displays the images at a large size, and if you click on an image during the slideshow it zooms in to 100% magnification – perfect for reviewing fine details or facial expressions.

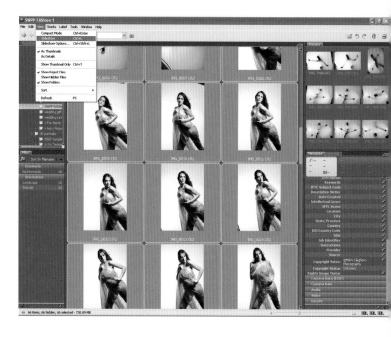

1 First, select some or all of your images in Bridge, then go to *View > Slideshow* or use the keyboard shortcut Ctrl/Cmd+L to start the slideshow.

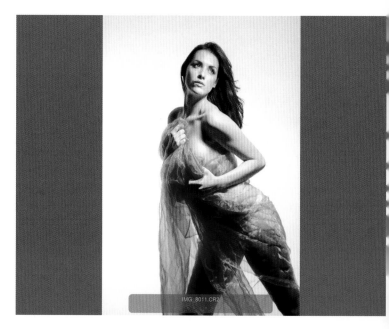

2 The slideshow will advance automatically. To pause it, press the Space bar. To go to the next slide, use the Right or Down arrow key. To go back, use the Up or Left arrow keys.

3 You can apply labels and star ratings to images in exactly the same way as described on page 39, even while a slideshow is in progress. Press the 1–5 keys for stars and the 6–9 keys for coloured labels and they will appear on the image caption.

4 When all the images have been reviewed, the slideshow will end and you will be returned to the main Bridge window. To leave the slideshow at any time, press the Escape key.

***Tip**

Go to *View* > *Slideshow Options* to set transition effects and slide duration. You can even adjust these while a slideshow is in progress by pressing H on your keyboard to open the *Slideshow Options* dialog box. Press H again to hide it.

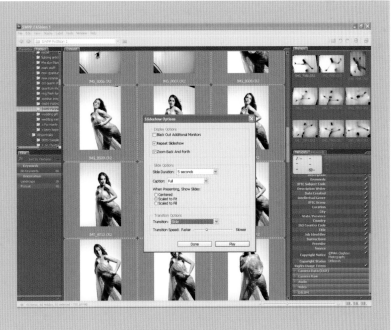

Deleting image files

As you're editing your images, it's a good idea to assign a colour to images that you don't want to keep, as this makes it easy to select the images destined for the trash. I use the red label – number 6 on the keyboard. Here's how to do it.

> ***Tip**
> Folders can be given a colour label in the same way as individual files, so it's a good idea to apply a red label to the Deleted folder, too.

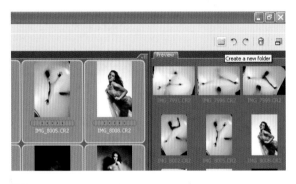

1 When you have labelled all of your unwanted images, click the *Create a new folder* icon at the top right of the Bridge window and a new folder will appear. I name this folder Deleted – not Einstein stuff I know, but easy to remember. Select the red label in the *Filter* panel, and only the images with a red label should be visible on the desktop.

2 To select all of the chosen images, go to *Edit > Select All* or press Ctrl/Cmd+A on the keyboard. Now all the red label images are selected, but the new folder is also selected, so Ctrl/Cmd+click on the folder to deselect it.

3 All the red label files can now be dragged into the Deleted folder.

4 Uncheck the red label in the Filter panel so that the remainder of your images are displayed.

Renaming image files

Bridge can rename batches of files in the blink of an eye. It's good practice to do this after you have completed your first edit of a shoot or import, so that each image has a name that's relevant to its content. This will help you locate images and prevent confusion in future.

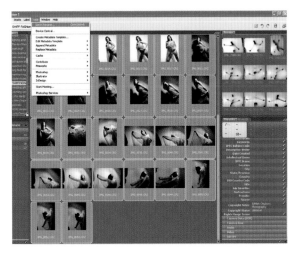

1 Select all the files to be renamed by going to *Edit > Select All* or pressing Ctrl/Cmd+A on the keyboard.

2 Go to *Tools > Batch Rename* or use the keyboard shortcut Ctrl/Cmd +Shift+R. A new dialog box appears called *Batch Rename*, with various options available. For the *Destination Folder* option, I usually choose *Rename images in same folder*. Select another folder if you want the renamed images to be stored elsewhere. Enter a suitable name in the *New Filenames* box. If names and numbers are to be used, click the + icon to add another section to the filename.

For example, let's say the images are to be named in a series starting with MCP 001. Select *Text* in the first box and type in MCP, followed by a space. Click the + icon and select *Sequence Number*. Type in the number 1, and select *Three Digits* in the *Quantity* dialog box.

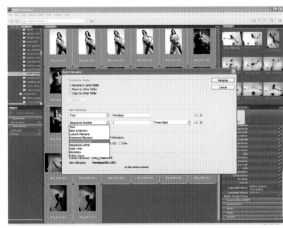

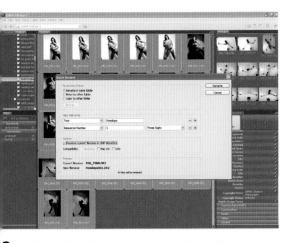

3 Check the Preview at the bottom to make sure the new filename is correct. Click the *Rename* button and all your images will be automatically renamed in sequence.

4 The files now appear in Bridge with their new filenames.

ADOBE CAMERA RAW – BASIC 1

RAW files remain as flexible as they are because they don't process or 'fix' the colour information in the image when it is shot. However, this means that only a few programs can deal with them – for most general photographic purposes they need to be converted into a more workable file such as a JPEG or TIFF. That's where Adobe Camera Raw comes in.

Initially, you might think 'why bother processing RAW files when the camera could just do the processing for me?' Quality and recovery are the answers – a processed RAW file will result in a much better-quality file than an in-camera JPEG, and you also have the advantage of being able to recover information from an overexposed image.

To process a RAW image, go to *File > Open* in Adobe Camera RAW or double-click one of your RAW files. The image will open in Adobe Camera RAW.

The intial screen is the most important when you're first getting to grips with Adobe Camera RAW. The Basic panel on the right-hand side holds the key to correcting

exposure and recovering detail in your images, while at the top of the screen you will find the icons for correcting colour, cropping and retouching. Even though you can now carry out cropping and basic retouching tasks in Adobe Camera Raw, I usually perform these tasks in Photoshop itself unless I have to crop a large group of files or remove dust spots from an entire shoot.

In workflow terms, the top of the screen and the panels on the right are set out in a logical order that you can follow through from start to finish. However, the secret is to do as little as possible – so try to get it right in camera first.

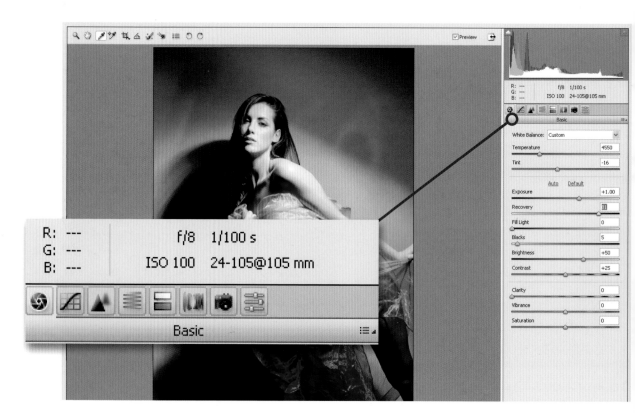

By default, Adobe Camera Raw opens at the Basic controls. These are all you will need to begin with.

Correcting the colour balance

1 To correct the colour balance in a RAW image, select the White Balance Tool (shortcut I), which is shaped like an eyedropper.

2 The White Balance Tool needs a neutral grey colour to analyze so that it can set the colours accurately. Click on a neutral tone in the image – if you don't have a grey, either select a white with detail or a black with shadow detail and click. This should automatically give you a far better tone and colour in the image, removing any colour cast.

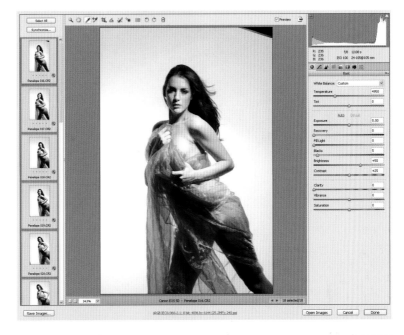

3 This adjustment can then be applied across a selected folder of images or to a selected few by Shift+clicking or Ctrl/Cmd+clicking on the images in the thumbnail panel at the side.

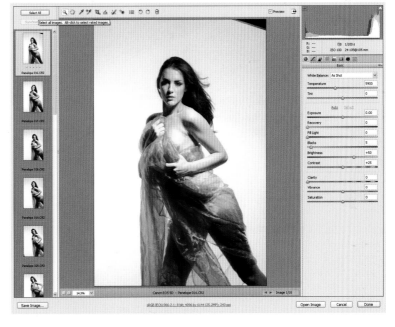

*** Tip**

JPEG files can be adjusted in Adobe Camera RAW in exactly the same way as a RAW file, with the exception of the detail and exposure recovery functions.

ADOBE CAMERA RAW – BASIC 2

The power of Adobe Camera RAW allows you to accurately adjust the exposure of the image after capture. You can also recover detail in the highlights and shadow areas that would previously have been lost forever. Contrast and midtones in the image can also be corrected with a swipe of a slider, but remember, less is more – do a little at a time.

An original RAW image.

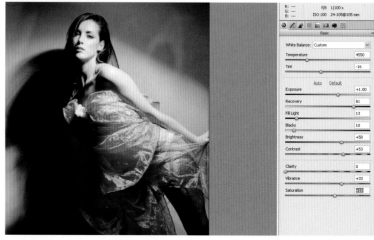

The sliders in the Basic panel use the information contained in the RAW file to produce different effects. Experiment until you achieve the desired result.

The Exposure slider

If an image is underexposed, you can recover some of the image detail in Photoshop. If an image is overexposed, it is much more difficult to do this because overexposed highlights contain no picture information that Photoshop can work with. A RAW file, on the other hand, has an almost full recovery potential of 1.5 stops. Even though Adobe Camera RAW looks like it has +/-4 stops of recovery, at this level the image becomes excessively contrasty and skin takes on a metallic look. To adjust exposure in Adobe Camera RAW, simply move the Exposure slider to the left or right.

+1 stop exposure adjustment

-1 stop exposure adjustment

The Recovery slider

The Recovery slider allows you to recover some of the detail that is lost as you change the exposure level (this is known as clipping). The Recovery slider works best when you are increasing the exposure of the image because there is more detail in the image to bring back – that's why it is always better to have an underexposed image than a severely overexposed image.

The Fill Light slider

The Fill Light slider basically opens up the midtone areas. Be careful when applying this slider, as it will degrade the image in print by making more of the image noise visible.

The Blacks slider

Be gentle when adjusting the Blacks slider, as this sets the black point in the image. Use the Alt key with this slider for a more accurate setting, especially if you are working on an uncalibrated monitor. Don't worry about making mistakes with RAW files at this stage, as your adjustments are non-destructive.

The Brightness slider

This is a useful control when an image is overexposed. As you decrease the Exposure slider, increase the Brightness slider to balance out the tone of the image.

The Contrast slider

Most digital cameras produce a slightly flat-looking image due to lack of contrast, and the Contrast slider can help to bring some contrast back. However, this is an overall adjustment to the whole image and not to a specific tone like the Exposure and Blacks sliders.

The Clarity slider

This new addition to Adobe Camera Raw is perfect for adjusting the midtone contrast in an image, instantly giving the photograph more punch.

The Vibrance slider

The Vibrance slider is useful for intensifying less saturated colours, while having a lesser effect on more highly saturated colours. It is useful for making skin tones more vivid without appearing unnatural.

The Saturation slider

This increases the saturation of all colours equally, from monochrome at the far left setting, to double saturation at the far right. Overdoing the saturation can introduce unnatural colours to an image, especially on skin tones.

Recovery adjustment

Fill Light adjustment

Blacks adjustment

Brightness adjustment

Contrast adjustment

Clarity adjustment

Vibrance adjustment

Saturation adjustment

ADOBE CAMERA RAW – ADVANCED 1

There is far more to Adobe Camera RAW than just exposure correction and detail recovery. Once you have familiarized yourself with the sliders in the Basic panel (see pages 44–7), you can move on to the more advanced settings. However, if you really are setting out to learn Photoshop in a single weekend, you might want to return to the more complex adjustments at a later date.

Tonal Curve

There are two styles of adjustment in this dialog box – a Parametric option with four sliders, and the Point tab, which is similar to Curves in Photoshop. The tonal curve is essentially a contrast adjustment, but the benefit of a curve adjustment is that specific areas of either highlight or shadow can be targeted and adjusted individually – unlike Levels in Photoshop, or the basic exposure and contrast adjustments discussed on pages 44–7.

When you have plotted a curve adjustment you like, you can save it and apply it to other files.

Sharpening

Sharpening can be applied to an image before processing, especially if an image is slightly blurred and you wish to go straight to print without further editing. However, sharpening is always best left until any image enhancement has been done in Photoshop and is always the last thing to be applied – if at all.

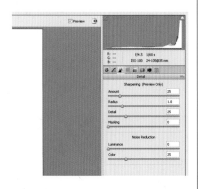

Apply Sharpening in Preview Only mode if you plan to make further adjustments to your image.

Noise Reduction

If you shoot at a high ISO, you may get patches of red and green spots known as noise. This is similar to grain on a film but uglier and more annoying. Careful use of the Color or Luminance sliders can decrease some of this colour noise.

Original image

Adjusting the Color slider makes the noise less obtrusive.

Adjusting the Luminance works well if the noise is in the shadow areas, but it can make an image look soft.

Tip
An even better solution to the noise problem is Noiseware Pro, a third-party Photoshop plug-in.

SL/Grayscale

ue, Saturation and Luminance adjustments are useful r adjusting specific areas of colour – as in this shot, here the blues and yellows have had major adjustments increase their luminosity, but not their saturation. This der keeps the colour looking realistic.

HSL/Grayscale adjustment

rayscale

e Convert to Grayscale checkbox can be useful, pecially if you're using using the Split Toning option in e next palette, or just want to go straight to mono from AW – or to adjust a TIFF or JPEG. Even when Convert Grayscale is checked, changing the colour sliders justs the contrast in the image.

Grayscale adjustment

plit Toning

e Split Toning palette is great for giving shadow and ghlight areas different colour tones. Choose the colour ne you require, and then use the Balance slider to give a eference of tone to either the highlight or shadow areas. e Saturation sliders control the amount of tone that is plied to each area.

Split toning

ADOBE CAMERA RAW – ADVANCED 2

To use RAW files in other software applications and for the web they need to be converted to another file format, the most popular being a JPEG. However, if you know you will be doing a lot of retouching to an image it is better to process the file to the lossless TIFF format, or, if you are planning to use layers, convert it to a PSD.

At the bottom of the screen in Adobe Camera Raw there is a line of blue text and numbers. Click on this line to bring up the Workflow Options dialog box, where you will find all the development settings that will be applied to the file when it is converted – this includes its colour space, the bit depth, the target file size and its resolution when the image is opened up in other software. Let's look at these options one by one.

Space

Choose the colour space you want to use in Photoshop when your file is converted, as this will start your workflow correctly. The colour space should usually be sRGB for most photo labs and desktop printers.

Depth

The colour depth is usually set to 8 bit, unless an image is really in need of a lot of work in Photoshop; 16-bit colour will allow more alterations in the tonal curve before further loss of information in the file. However, many of Photoshop's tools and features are not available to a 16-bit file and the image is approximately double the file size, so Photoshop will run more slowly when applying any changes, especially filter effects.

Some tools and features are not available in Photoshop when the file is processed as a 16-bit image. These will be greyed out in the menus.

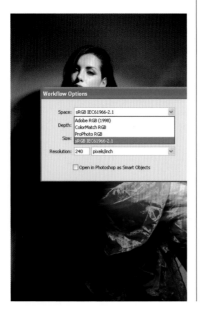

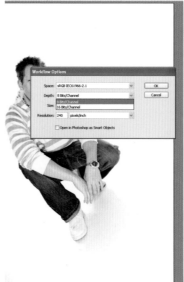

Size

The next option is to set the size of the file. By default, Adobe Camera RAW sets the size based on your camera's megapixel count, but you have the option to process the file to a smaller or larger size if required. Smaller is perfect for websites and web galleries, as this may save time later on in Photoshop with any post-production resizing. However, I always process at the camera pixel size and then reduce the file size after any manipulation in Photoshop. Making the image larger is a last resort, as this will interpolate (add pixels to) the file, and this can adversely affect the image quality.

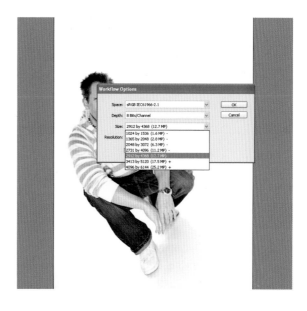

Resolution

This is usually set to the size at which you are planning to print. For most inkjet printers, the resolution is 300dpi, as it is for professional printing, but many photo labs have a required dpi of 240, so check up on what you need.

Setting the Resolution does not change the file size, it just sets the size at which the image opens up on screen. For example, the same 12.7 MP file processed at 240 dpi will open up as 12.1×18.2in (31 x 46cm), whereas if the file is processed at 72dpi it will open up as 40.4×60.7in (103×154cm).

Summary

So, what should have you learned in this first section?

■ First of all, you should make sure you are familiar with the Photoshop, Bridge and Adobe Camera RAW menus and controls, and the general areas in which the basic editing tools can be found. The more you use the software, the easier this will become, until it's almost second nature – just like learning a new language.

■ Colour correction will become quicker and more efficient the more you practice, but the basic techniques covered in this chapter will make it easier to achieve accurate images every time. Using the Adobe Camera RAW window will make it far simpler to correct any colour casts in RAW, JPEG and TIFF files.

■ Understanding file formats is essential, because each format is appropriate for different purposes. Before you convert a RAW file from your camera you will need to decide what you intend to do with it.

■ Learn the keyboard shortcuts one at a time. Learning just one an hour initially will save you many hours in the long run, as you'll be able to complete standard operations much more quickly.

Checklist

HOUSEKEEPING

- ❏ Set up your digital camera

- ❏ Calibrate your monitor

- ❏ Download images from camera to computer

- ❏ Make first backup of images

USING BRIDGE

- ❏ Set up Bridge

- ❏ Edit images using coloured labels

- ❏ Rename images

USING ADOBE CAMERA RAW

- ❏ Colour-correct images

- ❏ Correct exposure and contrast

- ❏ Back up RAW images

- ❏ Set colour space

- ❏ Set bit depth and size

- ❏ Set resolution

- ❏ Process RAW files to working files

- ❏ Back up processed JPEG files and unprocessed files

Basic Corrections

As a photographer, there are certain simple corrections that you will need to perform on almost every image: cropping and rotating, adjusting the exposure, tweaking the colour, and basic retouching to remove imperfections. This may sound arduous, but you will soon become familiar with the standard Photoshop techniques required to perfect your photographs. In this chapter, these key skills are presented in a logical order that shadows an image's journey from capture to output. By following this set procedure in Photoshop, images can be corrected in a blink of an eye.

- **EXPOSURE AND CONTRAST**

- **EXPOSURE – SELECTIVE ADJUSTMENTS**

- **COLOUR ADJUSTMENTS**

- **RETOUCHING**

- **ADVANCED RETOUCHING**

- **CROPPING AND ROTATING IMAGES**

- **CROPPING TO A SIZE**

- **RESIZING AND INTERPOLATION**

- **SHARPENING**

- **SHARPENING SETTINGS**

- **SUMMARY & CHECKLIST**

EXPOSURE AND CONTRAST

The images produced by digital cameras often look a little flat and lacking in contrast compared to those taken on film. Digital cameras have preset shooting modes that produce more or less contrast in an image, but despite this, the first thing you may want to do to an image is adjust its contrast. The most effective way to adjust the contrast over an entire image is to use the Levels control.

Levels
Image > Adjustments > Levels
Keyboard shortcut: Ctrl/Cmd+L

The Levels control is the simplest way to adjust a colour cast and the shadow and highlight areas in an image to give better contrast. The basic Levels adjustment is destructive – in other words, you will lose image data when you apply it. Therefore, it should only be applied once to an image, and you should always make sure you keep a copy of the original file in its untouched state in case you wish to create a different effect at a later date.

1 From the main menu, go to *Image > Adjustments > Levels*, or use the keyboard shortcut Ctrl/Cmd+L.

2 In the resulting dialog box you will see a histogram, or graph, that represents the range of tones in your image, and a selection of controls.

3 Select the middle eyedropper icon on the right-hand side of the Levels dialog. This is the grey point picker, and it will set the midpoint in the image's range of tones and at the same time correct any slight colour cast. Click on an area of your image that should be a neutral colour, and the rest of the tones in the image will be adjusted accordingly. In this image, I clicked on the duck's head to remove the yellow cast from the afternoon sun and the blue cast reflected off the water.

4 Next, set the black point. This will have the greatest effect on my duck image, and as long as your monitor is calibrated properly (see page 20) you will get accurate contrast and colour every time.

Slowly drag the small black triangle on the left-hand side of the histogram to the right. This will gradually move the darkest parts of the image closer towards black, and should usually be set to the first incline on the mountain range of the histogram.

5 Now set the white point, moving the lightest tones in the image towards pure white. Drag the white-point slider, which is on the right-hand side of the histogram, towards the middle slowly – this time to the start of the first peak.

6 When you're satisfied with the result, click OK. The image has now had its contrast set and any colour cast removed. But beware, this alteration can result in very contrasty effects. If you overdo the adjustments it will result in shadow and highlight areas with no detail, referred to as clipping, or blocked blacks and blown highlights.

If you are working on an uncalibrated monitor, press and hold the Alt key while you drag the two sliders. This will show a clipping mask, which will show how the image is going to be clipped as you alter the highlight and shadow areas.

***Tips**

Try the Auto Levels option for a quick fix (*Image* > *Adjustments* > *Auto Levels* or keyboard shortcut Shift +Ctrl/Cmd+L). It doesn't work for every image, but is often worth a try.

Use a Levels Adjustment layer (*Layer* > *New Adjustment Layer* > *Levels*) for a non-destructive adjustment to an image. An adjustment layer is fully editable without loss of quality or image data until the image is flattened.

When using the sliders in the Levels dialog, the middle slider – which is for adjusting the midtones – will drastically change the image, even when it is moved slightly. Only use the middle slider as a last resort.

The Curves command (*Image* > *Adjustments* > *Curves* or keyboard shortcut Ctrl/Cmd+M) is another way to alter the contrast in an image. However, Curves is an extremely sensitive tool and it takes a lot of practice to use it successfully.

EXPOSURE – SELECTIVE ADJUSTMENTS

The classic darkroom techniques of 'dodging' and 'burning' areas of an image during development have survived in digital form in Photoshop. Dodging lightens a specific area of the image, while burning darkens it. This is a simple but amazingly effective skill that many professional photographers will use to enhance almost every image.

The Dodge tool
Keyboard shortcut: O

Dodging is the technique of lightening an area of an image that is slightly too dark. This can often happen, even when an image has had its contrast set correctly.

1 Select the Dodge tool from the Tool Bar – it's the one that looks like a black disc on a stick and is at the bottom of the second section of tools. With the Dodge tool selected, the Tool Options Bar at the top becomes available. This is where you select how the tool behaves, as well as the brush size and sensitivity.

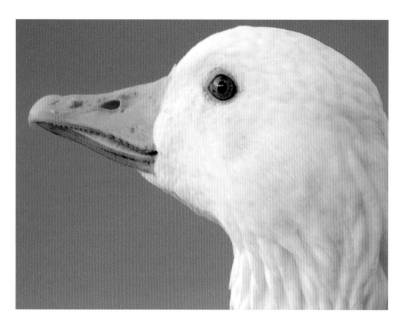

2 For the duck's eye, I selected the *Highlights* option from the *Range* field on the Tool Options Bar so the light parts of the eye would be lightened even more. The brush size is set by clicking *Brush* on the Tool Options Bar and adjusting the sliders, or by pressing the left square bracket ([) on the keyboard to decrease the size, or the right square bracket (]) to increase the size.

3 Apply the tool by clicking on the image and rotating the circle over the area to be lightened. To achieve the best results, set a low *Exposure* value on the Tool Options Bar and repeat the process several times. Setting a high *Exposure* value may result in an overly harsh adjustment.

***Tip**
Dodging and burning – along with many other techniques in Photoshop – can be easier if you use a graphics tablet and pen, such as those produced by Wacom, because the sensitivity of the selected tool is adjusted by the pressure you apply to the nib of the pen.

The Burn tool
Keyboard shortcut: O

Burning an area means darkening it, either to increase detail or to lose detail completely as an area nears black. While loss of detail may at first seem undesirable, the technique is often used to darken large areas that are a distraction in an image, or to draw the viewer's attention to a specific area of the photograph.

1 Select the Burn tool from the Tool Bar – it's the one that looks like a hand in a pinching motion. The Burn tool is found in the same square as the Dodge tool – click on the little arrow icon on the corner of the square and select the Burn tool from the pop-up menu that appears (the Sponge tool is also found in the same square).

As with the Dodge tool, define the Burn tool's behaviour in the Tool Options Bar. For the best results, choose a soft-edged brush so the transition from the original image to the darker area is subtle. The tool should be applied gradually for the best effect and in either rotary or sweeping motions.

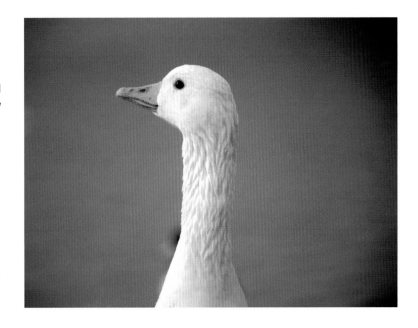

3 In this image, I burnt in the detail on the beak, especially around the shadow areas of the mouth, with a very small, soft brush. I used a very large soft brush to burn down the edges of the image to give it a vignette look, as if the duck had been spied through a looking glass.

***Tip**
The Dodge and Burn tools are both found in the same square on the Tool Bar, and share the same keyboard shortcut – O. The tool whose icon is shown in this square is the one that will be activated by the keyboard shortcut. To toggle between tools that share the same shortcut, hold down the Shift key while pressing the shortcut.

COLOUR ADJUSTMENTS

There are many ways to adjust colour in Photoshop, some more complicated than others. First, we'll look at a simple but effective way to see and alter the overall colour balance in an image. Then, on page 62, we'll move on to methods for adjusting individual colours or ranges of colour within an image.

Variations

Image > Adjustments > Variations

The Variations method is derived from the simple 'ring around' technique that was used in photo labs to assess and change colour in an image. The auto analyzer in a photo-lab printer works on the same principle as a camera's automatic white balance, looking at the overall scene and trying to obtain a neutral tone by adding or subtracting colour, because reflected light from, say, bright green grass or a red door would produce a slight colour cast. Similarly, with Photoshop's Variations control, you can easily add a little or a lot of one or more colours to affect the entire image.

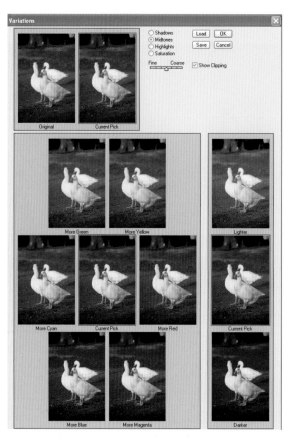

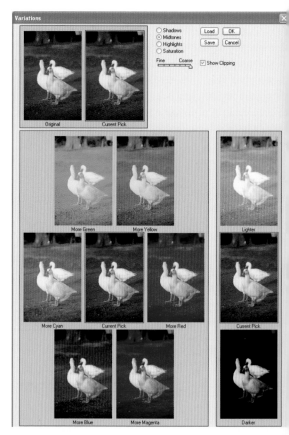

1 Go to *Image > Adjustments > Variations* to open the Variations window. This window has several options. The first are the radio buttons to select *Shadows*, *Midtones*, *Highlights* or *Saturation* – selecting one of these chooses which range will be affected by your adjustment. The *Fine – Coarse* slider below the buttons changes the degree by which the image is adjusted each time you click on it.

2 Click on the thumbnail image that corresponds with the effect you want to achieve and you will see the effect side-by-side with your original at the top of the Variations window. If you select the *Coarse* end of the slider, as shown here, the colour and density of the image will change drastically. It is always better to work in small increments and gradually work towards the result you want.

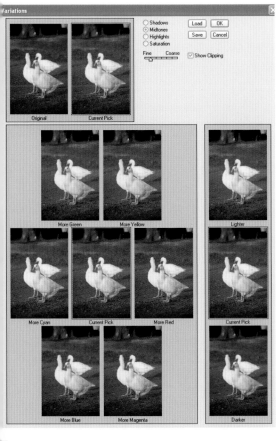

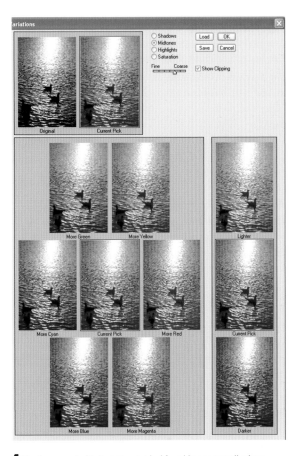

3 Here, with the slider at the *Fine* end of the spectrum, I clicked the *More Blue* image twice, the *More Cyan* image once, and the *Lighter* image once. This was done to compensate for the very yellow sunlight on the ducks – in colour terms, the opposite of yellow is blue, so by clicking on *More Blue*, there will be less yellow in the image.

4 The *Coarse* control in Variations is ideal for adding an overall colour cast to an image, changing the overall mood of the scene. This works particularly well with silhouettes. Here, I added a warm red glow.

5 If your image is black and white, then you can add a colour cast to your image using the Variations palette. Simply click on the desired tone and keep clicking until you achieve the look you want.

Tip

Use this technique to learn to understand opposite colours and to see clearly how changing one colour affects the others.

To revert to your original image while still in the Variations window, double-click on the original.

If you have converted your image to Grayscale mode in Photoshop, the image cannot have any colour added. To add a colour cast using Variations, remember to turn the image mode back to RGB (*Image > Mode > RGB*).

Hue/Saturation
Image > Adjustments > Hue/Saturation
Keyboard shortcut: Ctrl/Cmd+U

Digital cameras sometimes oversaturate an image with an increase in the warmth and saturation of the colour, often leading to lobster-red skin and unrealistic tones in the scene. A quick fix for this type of image is to use the Hue/Saturation sliders found under Image > Adjustments.

1 Go to *Image > Adjustments > Hue/Saturation* or press Ctrl/Cmd+U to open the Hue/Saturation dialog. Drag the *Saturation* slider to the left to remove some of the colour. A value of between -10 and -17 will usually fix the problem of red faces, but the adjustment is applied across the whole image, and the image can lose its punch if the master saturation is used.

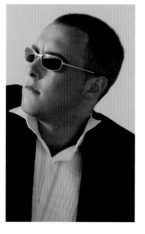

Before **After**

2 To adjust a specific colour or colours in the image, select the desired colour from the *Edit* drop-down menu. In this case, only the reds and magentas need to be adjusted to remove the lobster warmth.

3 To make subtle changes to the colour of an image, especially skin tones, try moving the master *Hue* slider to between -1 and -4. This tends to remove any slight yellow cast, instead replacing the look with a warm, reddish tone that's far more pleasing.

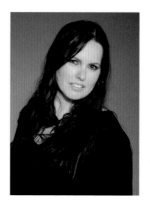

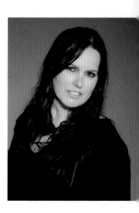

Before **After**

Color Balance

Image > Adjustments >
Color Balance
Keyboard shortcut: Ctrl/Cmd+B

Another way to apply colour changes is to use the Color Balance adjustment sliders. These modify six colours: Red, Green and Blue and their opposites Cyan, Magenta and Yellow.

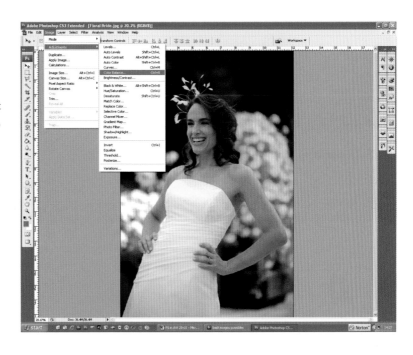

1 Open the Color Balance dialog and adjust the sliders until you achieve the desired result.

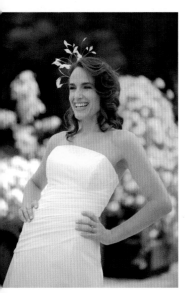

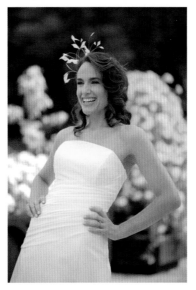

2 To use the Color Balance control successfully you should always leave one of the sliders alone, as adjustments to the other two sliders affect the way that the remaining colours appear in the image. Here, I moved the sliders towards Red and Yellow to warm up the image.

3 To cool the same image down, I moved the sliders further towards Green and Blue.

> ***Tip**
> When adjusting images with the Color Balance sliders, tick the *Preserve Luminosity* checkbox to ensure the image keeps its vibrancy. This is especially important with skin tones.

RETOUCHING

The power and flexibility of Photoshop really shines when it comes to retouching your images. The wide array of retouching tools in Photoshop makes it easy for photographers to enhance images by removing flaws and ugly areas that cause distraction to the viewer or disappointment to the subject.

The retouching tools are found in the Tool Bar and are in the second section of tools from the top. The Spot Healing Brush Tool, Healing Brush Tool, Patch Tool and Red Eye Tool are all found together in the same square on the Tool Bar. Press J on the keyboard and scroll through the tools by either pressing the J key again or by pressing and holding the Shift key at the same time, depending on your setup.

Red Eye Tool
Keyboard shortcut: J

The Red Eye Tool, even though it's found at the bottom of this tool's pop-up menu, is usually applied first to quickly remove the familiar red-eye effect caused by a flash. To use the Red Eye tool, simply select it from the Tool Bar and click on the red eye in your image. The correction is made automatically and takes milliseconds. There are some further options on the Tool Options Bar but you will only need to adjust these if the eye is very small in the picture.

Before

***Tip**
The retouching tools all have options in the Tool Options Bar to change their characteristics.

After

Spot Healing Brush
Keyboard shortcut: J

The Spot Healing Brush is perfect for removing dust spots and minor facial flaws. It is very effective in instantly zapping zits, as the tool samples an area close to the blemish and then blends the pixels, making it near-perfect almost every time. Be careful with your brush size, as too large a brush will give a blotchy look as well as adding detail from around the area, such as hair. Use a brush just bigger than the dust or spot you want to remove.

Before

After

Healing Brush
Keyboard shortcut: J

The Healing Brush is also used for dust and spot removal and works in the same way as the Spot Healing Brush, with the exception of the area the brush samples from to heal the affected area. To use this tool, Alt+click the area you wish to sample from, and then click the area you want to retouch. The blemish will be replaced by the sampled pixels. This tool is perfect for applying texture or tone to a specific area, and is similar to the Clone Stamp Tool (see page 66).

The crosshair determines where the sample is taken from each time you click with the Healing Brush.

Patch Tool **Keyboard shortcut: J**

To remove wrinkles and darkness under the eyes, use the Patch Tool. This simple technique will make your subjects look younger and less tired, but beware – overdoing it will make the face look fake. To use the tool, select the Patch Tool from the Tool Bar and draw around the area you wish to correct (you don't need to be too precise). When you have selected the area, drag it to the location you want to patch from – in this instance the cheek, as it has a similar tone. Release the mouse button and the area will be patched. You can use this tool with any predefined selection, such as one that you have made with the Marquee Tool (see page 90).

First, select the Patch Tool and draw around the area you wish to correct.

Then drag the selected area to the area you want to copy and release the mouse button.

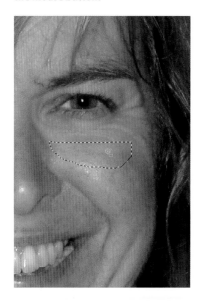

Clone Stamp Tool
Keyboard shortcut: S

The Clone Stamp Tool is used for copying texture and painting out larger areas, as well as facial retouching. In this example, I will use it to retouch out the Lastolite reflector on the right-hand side of the image.

Before Clone Stamp Tool

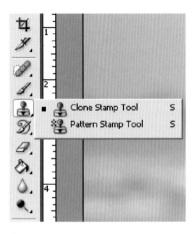

1 Select the Clone Stamp Tool from the Tool Bar (it looks like a rubber stamp) or press S on the keyboard.

2 Define the area that the Clone Stamp Tool will sample. To do this, press the Alt key and the cursor will change from a small circle (representing your brush size) to a crosshair. Position the crosshair where you want the Clone Stamp Tool to copy from and click the mouse.

3 The cursor changes back to a circle and you can start painting over the area you want to replace. As you paint, you will notice the crosshair following your movements. If your brush size is too big, or if the area you are cloning from is too close to the edge of the brush, the process will not be successful, so take your time initially when selecting the source point. Try to choose an area with similar tone and texture, as the Clone Stamp only puts in what it is copying from. Look out for any awkward shadows or highlights.

4 Choose a soft-edged brush from the *Brush* menu on the Tool Options Bar to make the cloning less obvious. Painting with the Clone Tool is simple once you get the hang of it, and unwanted areas of an image will disappear in seconds. This tool is ideal for painting out litter or other distractions, as well as cloning detail into an area, such as reflections in windows.

5 There are other options in the Tool Options Bar to determine how the brush will behave. *Opacity* is the most important option, as this controls the depth of the effect as you are painting. Change the *Opacity* by using the slider in the Tool Options Bar or by pressing the numbers 1 to 9 on your keyboard – this will change the opacity automatically to 10%, 20%, etc.

6 Repeating patterns may occur if you copy an area with a defined pattern, such as the stones on the sand in this image. When cloning larger areas, click different parts to define different source points and go back over some of the area to disguise the effect.

7 The final image has had some of the stones cloned out as well as some of the reflections on the water – in other words, anything that the eye is drawn to that distracts from the intended focal point of the picture. Take care when using this tool, as you can get carried away and clone out too much detail, making the image look a little artificial.

After Clone Stamp Tool

ADVANCED RETOUCHING

The Liquify Filter technique is too good to miss out – it's perfect for making double chins disappear in profile and for slimming down hips, legs and arms. However, as this is a more advanced technique, you may prefer to return to this page at a later date – otherwise you'll be playing with it all weekend, and that's not the goal of this book!

The Liquify Filter
Filter > Liquify
Keyboard shortcut:
Shift+Ctrl/Cmd+X

In this image, the chins are a little heavy and floppy on both the parents, but that's a problem easily solved by using the Liquify Filter.

Before Liquify Filter

1 Open the image to be corrected in Photoshop, and open the Liquify Filter dialog box by going to *Filter > Liquify* or using the keyboard shortcut Shift+Ctrl/Cmd+X.

2 The Liquify window may look a little daunting at first but with this technique you only need to remember a few key sections. First you need to get up close to the area you want to correct using the Zoom tool, which has a magnifying glass icon (or use the keyboard shortcut Z).

3 Select the Pucker Tool. This tools 'sucks' pixel inwards in the direction of the brush stroke – in this case, towards the face.

4 Each time you click the mouse, the flabby skin is gradually pushed inwards. Don't rush this technique – little and often is the best approach if you want to retain a realistic look. Remember to zoom in and out to check the effect; it's very easy to go overboard and end up with an image that looks too obviously retouched.

5 When you have finished, click *OK* to return to the main Photoshop window. In this example, zooming in close to the retouched area reveals that the Pucker tool has sucked the textures toward a visible point, like water going down the plughole (hence the term 'Liquify').

6 This problem is easy to correct. Select the Eraser Tool from the Tool Bar and click the *Erase to History* box on the Tool Options Bar. Slowly move the Eraser over the affected area, bringing back any detail that was lost. Stay away from the edges of the face unless you are working close up with a small brush.

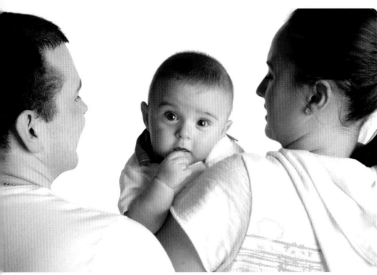

After Liquify Filter

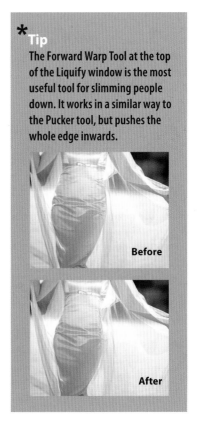

***Tip**

The Forward Warp Tool at the top of the Liquify window is the most useful tool for slimming people down. It works in a similar way to the Pucker tool, but pushes the whole edge inwards.

Before

After

7 The final image has removed some of the unflattering bulkiness from the parents' chins, but still looks realistic.

CROPPING AND ROTATING IMAGES

Cropping and rotating are creative techniques in themselves – crucially, they determine how your subject is positioned in the frame. Always save your a copy of your original file before cropping or changing the image size in any way, or the areas you remove will be lost forever.

Using the Crop Tool
Keyboard shortcut: C

Cropping is easy in Photoshop, but first you must think about what you are planning to do with the image: if it's for printing, do you want to fill the print area, or do you need blank canvas at the sides or at the top to make up the photo lab's set sizes? The same applies if the image is to be framed – it's far more expensive to have a print custom framed than to pick a frame off the shelf.

1 Open your image and select the Crop tool from the Tool Bar. Click and drag the mouse over the area too be cropped.

2 Don't worry if your selection isn't perfect, because until you double-click the mouse or press Enter to commit to the crop, the cropping bars are editable by dragging them in or out. You can move the crop box by clicking and dragging the box around the image, or change the overall size of the crop box by dragging a corner and expanding or contracting it. This is perfect for composition adjustments.

Before cropping **After cropping**

3 The crop box can be rotated to correct any horizontal or vertical discrepancies. Move the cursor to the corner of the crop box and semi-circular arrows will appear. Drag these arrows to rotate the box to its new position. When you're done, double-click the mouse or press Enter to commit to the crop.

Before rotation **After rotation**

Rotating an image with the Ruler Tool
Keyboard shortcut: I

Even though an image can be rotated during cropping to accurately realign it, the best technique is to rotate the canvas before you use the Crop Tool. In this image, the roof of the building looks obviously crooked, so I'll correct it with the Ruler Tool.

1 Select the Ruler Tool, which is hidden under the Eyedropper Tool on the Tool Bar, or press I on the keyboard and then Shift+I to scroll through the options to the Ruler icon. With the Ruler Tool selected, drag the cursor to draw a line along the horizon or vertical at the desired angle.

2 To apply the desired rotation, go to *Image > Rotate Canvas > Arbitrary*.

3 A dialog box will appear with the angle you set with the Ruler Tool already shown. Click *OK*, and the image will be rotated. At the same time, the canvas size will be increased to compensate. This method takes all the guesswork out of correcting verticals and straightening horizons.

4 Now that the image orientation is correct, the Crop tool can be applied to remove unwanted areas at the edge of the frame.

5 The final image has corrected horizontals and a much more pleasing overall composition.

CROPPING TO A SIZE

As well as freehand cropping (see page 70), the Crop Tool can also be used to trim images to a predetermined size and resolution. This ensures that none of the image will be cropped out when you order prints at a photo lab – a common problem with freehand cropping because the lab will often have to enlarge or reduce the image to fit its standard sizes.

Once you have selected the Crop Tool from the Tool Bar, you can perform all of the following crops by selecting the relevant settings in the Tool Options Bar at the top of your screen.

All the crops described here will be performed on the same uncropped image, shown here.

Crop to Size

If you want to crop an image to, say, 8in wide by 6in high, simply type 8 in the *Width* box on the Tool Options Bar and 6 in the *Height* box (your default measurement must be set to inches in the Preferences). Then drag the cursor on the image and the crop box will appear. When you're satisfied with its position, double-click or press the Enter key to apply the crop. This is my preferred method of cropping because the only image information lost is that contained in the cropped-out area.

Crop to Size and Resolution

To crop an image to an exact size and resolution, add the desired resolution in the *Resolution* box on the Tool Options Bar as well as the desired height and width. This is ideal when you are saving an image to send to a photo lab, inkjet printer or email.

Crop to Preset Size

If you are cropping to a preset size, it is often quicker to save the crop settings as a Preset and then select the Preset from the drop-down box on the Tool Options Bar – when you click on the down arrow, your saved crop presets will appear in the list.

To save a crop as a Preset, type in your desired crop size with a resolution, if desired, in the usual way. Click on the Preset drop-down menu, click on the small arrow at the top and a new menu will appear. Click *New Tool Preset* and rename the crop. Keep the name simple so you can easily find what you are looking for in the menu.

***Tip**

If you set a resolution and a crop size bigger than the image itself, the image will actually be enlarged when you crop, and when you crop an image to a smaller size, the entire image gets smaller.

Image quality

Depending on the target resolution you set, the image can be cropped to the same physical size but the actual information in the file is dramatically reduced, which will obviously affect the quality. Check the optimum resolution for your purposes before cropping, as there's no need to have a huge, high-resolution file if your image is going to be printed at a small size.

If you look at the image size of the images below (this is done by selecting *Image > Image Size*), you can see that the pixel dimensions and the overall file size is different in each example.

RESIZING AND INTERPOLATION

Interpolation may sound complicated, but essentially it is just a way to increase the size of an image beyond its 'natural' size by adding extra pixels. However, this can adversely affect image quality and you must be aware of the dangers.

Interpolation

Interpolation is not a bad word, but it is a word that will affect your image quality. Enlarging an image beyond its natural size means 'faking' the picture – the computer surrounds each pixel with pixels of a similar colour to increase the overall dimensions of the image.

The first interpolation mistake usually occurs with the Crop Tool, when a target size bigger than the original is set. For instance, a 12.7MP (megapixel) file from my Canon 5D will give an image size of 4368×2912 pixels, or approximately 18×12in (46×30cm) at 240 dpi, which is around 36.4MB.

With a RAW file it is preferable to increase the file size at the processing stage – but this is a last resort and should not be normal practice.

If I want to increase the size of my 18×12in image to print a poster 24in wide, the width would be the target, so I'd enter 24 into the *Width* box in the *Image Size* dialog. This would increase the height to 16in, and if I kept the resolution the same – which I would need to do to get a decent print quality – the physical file size would be increased to 5760×3840 pixels with a file size of 63.3MB. This increase has to come from somewhere – and it comes from Photoshop interpolating, or adding pixels. This has an adverse effect on the image quality.

Interpolation really causes problems when you crop a small part of an image and increase it to a large size. If this is essential, your best option is to go back to the original RAW file and increase the file size before processing it to a JPEG or TIFF – but again, be aware of the loss of quality. This image has been increased from 100% to 132% and the quality loss is already visible in the lack of sharpness.

Above: Original image
Below: Enlarged and interpolated

Resizing down

Resizing or scaling an image down does no harm to the image quality unless you then try and resize it upwards again. This is another reason why it is good working practice to save an image before cropping and use the original to create other versions with different crops as and when you need them.

Front Image

If you have several images that you want to crop to the same size as another image which is already open, you can automatically set the size and resolution of the crop based on the open image into the *Width*, *Height* and *Resolution* boxes by pressing the *Front Image* button on the Tool Options Bar. When you apply the crop to each image they will all have the same characteristics.

Maintaining the picture ratio

This is a quick way to crop a section of the image while maintaining the original picture ratio.

1 Select the entire image by going to *Select > All* or using the keyboard shortcut Ctrl/Cmd+A.

2 Go to *Select > Transform Selection* and press and hold the Shift key while you transform the area by dragging the corners.

3 Move the box to the desired selection area and press Enter. This will leave a selection box in the same ratio as the original image.

4 Finally, go to *Image > Crop*. The cropped image will retain the same proportions as your original image.

SHARPENING

Image sharpening works by increasing contrast at the 'edges' within an image – not the borders of the image, but where an area of light pixels meets an area of dark pixels. Sharpening should always be the last stage of your image manipulation – and it is not always necessary, as some photo labs apply sharpening at the printing stage, as do some inkjet printers.

If you have applied an in-camera preset 'look' to a JPEG image when shooting, some sharpening will have already been applied in-camera. However, if you have shot a RAW file, sharpening can be applied in Photoshop or in Adobe Camera RAW. The reason why sharpening should always be applied as the final stage before output is so that any retouching or image manipulation you apply is not applied over a pre-sharpened image. This ensures that the image looks more natural and that any manipulation does not accentuate features such as over-sharpened skin or textures, especially around the edges where the sharpening is most apparent.

Unsharp Mask
Filter > Sharpen > Unsharp Mask

The simplest sharpening tool to use is the Unsharp Mask filter. This was originally introduced for scanned images and was based on a darkroom technique.

1 Open the Unsharp Mask filter by going to *Filter > Sharpen > Unsharp Mask* from the main menu.

2 A new dialog box will appear where you can adjust the sharpening values. The magnification window is set to 100% by default, but you can zoom in and out to preview the sharpening effect you have applied.

The three sliders in the Unsharp Mask dialog – *Amount*, *Radius* and *Threshold* – allow the sharpness to be applied in different ways. The *Amount* slider controls the degree of sharpening applied to the image and can be set from 1–500%. The *Radius* slider controls the number of pixels from the edge that the sharpening will affect, and can be set from 0.1–250 pixels. The *Threshold* determines how different a pixel must be from its neighbour to be considered an edge pixel, and hence sharpened, and can be set from 0–255. The *Threshold* works in the opposite way to the *Amount* and *Radius* sliders in that the lower the number, the more intense the effect.

HARPENING SETTINGS

How much sharpening you apply is a matter of taste, but I prefer it to be subtle rather than coarse. The following are some of the default Unsharp Mask settings I apply to particular types of images. Until you develop your own preferences, use these as a starting point.

General sharpening

This is my starting point for a 'general' image. This type of image would have a good quality and quantity of light. This degree of sharpening keeps the image looking realistic, and doesn't shout out 'I've been sharpened.'

Amount – 85%
Radius – 1
Threshold – 4

Before sharpening After sharpening

Soft subjects

This is for flowers, animals, people or subtle sunsets. When an image is soft by nature – not because it's out of focus – it is better to apply a softer sharpening, where only a little is applied to the brightest highlights.

Amount – 150%
Radius – 1
Threshold – 10

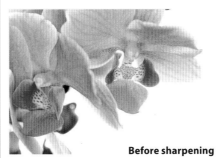

Before sharpening

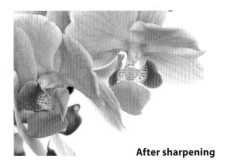

After sharpening

BASIC CORRECTIONS

Portraits

These settings are a good starting point for three-quarter and close-up portraits, as the sharpening brings a little glow to the highlights. For shiny skin or hair, increase the Threshold to around 8.

Amount – 80%
Radius – 2
Threshold – 3

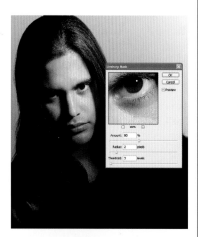

Moderate Sharpening

Another general set of sharpening settings that can be applied to a wide range of subjects – interiors, landscapes, products and even some portraits.

Amount – 125%
Radius – 1
Threshold – 3

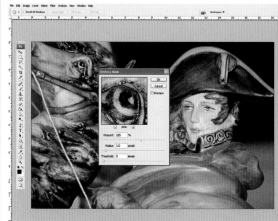

Before sharpening

Before sharpening

After sharpening

After sharpening

Maximum Sharpening

This setting is good for visibly out-of-focus images and images with defined edges, such as buildings, rocks and metal. Otherwise, use this setting with caution.

Amount – 65%
Radius – 4
Threshold – 3

Before sharpening

After sharpening

Web Sharpening

When images are reduced in resolution for the web they can become soft and fuzzy. Adding this level of sharpening gives them back some punch. On visibly out-of-focus images, try increasing the Amount to 400%.

Amount – 200%
Radius – 0.5
Threshold – 2

Before sharpening **After sharpening**

> ***Tip**
> Another good starting point when you're learning to sharpen is to remember the magic number 1-2-3 – 100% Amount, 2 Radius, 3 Threshold. This often provides a good starting point.

Summary

■ First, it's important to understand that there must be a logical workflow applied to your image-making. You must attack the process methodically so that you remember where you are at all times and don't waste time repeating yourself or undoing work you've already done.

■ Get the exposure of your images as near perfect as you can in-camera to minimize loss of detail. Then, when you use Photoshop's powerful tools to adjust colour and contrast, you will be enhancing your images rather than correcting them.

■ Retouching is a key skill, and an activity that many photographers enjoy, but try not to rely on a single tool. Learn to combine the different tools and use the most suitable tool for each task. Think about ways to work on small areas of the image rather than applying blanket adjustments.

■ Resizing an image or cropping to a desired size can result in a loss of quality if you make it bigger than its original maximum size, because Photoshop interpolates, or adds pixels, to the original image. Cropping should always be done at the camera stage first, when you compose the picture, to make sure that every pixel counts when you start manipulating the image in Photoshop.

■ And finally, keep learning the keyboard shortcuts one at a time, especially for retouching tools such as the Spot Healing Brush (J) and the Clone Stamp (S), and invaluable enhancement tools such as the Dodge and Burn Tools (O).

Checklist

ADJUSTING EXPOSURE AND CONTRAST

❏ Levels

❏ Auto Levels

SELECTIVE AREA ADJUSTMENTS

❏ Dodge

❏ Burn

ADJUSTING COLOUR

❏ Variations

❏ Hue & Saturation

❏ Color Balance

RETOUCHING

❏ Spot Healing Brush

❏ Healing Brush

❏ Patch Tool

❏ Red Eye Tool

ADVANCED RETOUCHING

❏ Liquify Filter

RESIZING AND INTERPOLATION

❏ Cropping

❏ Cropping to a set size

❏ Image Size

❏ Front Image

SHARPENING

❏ Unsharp Mask

Advanced Corrections

Now you know your way around the program and are familiar with some of its key concepts, it's time to delve a little deeper. The skills covered in this chapter, though more advanced than what we've covered so far, are still key skills. You'll use them frequently, so it's essential to get your head around them now.

We will deal with Layers first, as almost every other technique in Photoshop utilizes layers in one way or another. After that, the techniques presented are all of equal value, but some may be more suited to your style of photography than others, so feel free to pick and choose which ones to learn first. As usual, there's a Checklist at the end of this chapter so you'll know if you've missed anything out.

- UNDERSTANDING LAYERS

- LAYERS – ADVANCED

- MAKING SELECTIONS

- MASKS

- LENS CORRECTION FILTER

- FILTER EFFECTS

- BLACK & WHITE CONVERSIONS

- SPLIT TONING

- LIGHTING AND GRADIENT EFFECTS

- SUMMARY & CHECKLIST

UNDERSTANDING LAYERS

The skill of using layers is almost a book in itself. While you may not be able to master it in a weekend, you can certainly gain an understanding of how layers work, the power and flexibility they give you, and why you should use them when working on an image.

What is a layer?

Layers are the power behind Photoshop. They enable you to construct a single image from multiple sources, each of which can be moved or manipulated independently and all of which are controlled via the Layers palette.

Think of layers as pages in a book: the only image you can see in a book is the page at the top – that is, unless the pages are very thin or the page is semi-transparent, in which case you can see the images below. That is what layers allow you to do – change the opacity of the layer on top to affect the layer below it.

The Background layer

When you first open an image, the Layers palette only shows one layer, which is automatically called Background. The Background layer is locked by default, so you have to duplicate it in order to adjust it.

Creating a Duplicate Layer

When you are retouching or adjusting an image, you should always duplicate the original layer before you start, and make your adjustments on this copied layer. This is a safety net for recovering detail later.

Open the Layers palette, which is the square-above-square icon on the Tools palette on the right of your screen. You can also open the Layers palette by going to the main menu and selecting *Window > Layers*. To duplicate the layer, drag the Background layer in the Layers palette onto the *Create a New Layer* icon at the bottom of the palette and a duplicate layer is placed above the selected layer. This function has the keyboard shortcut Ctrl/Cmd+J.

The Layers palette in the image below shows the original image duplicated three times to give a total of four layers. A different look has been applied to each layer (see opposite), but the only one that is visible is the layer whose eye icon is switched on. This is done by clicking the eye icon on the Layers palette, toggling the layer visibility on and off.

LAYER 1
Original image

LAYER 2
High-contrast effect
applied

LAYER 3
Dry Brush effect applied

LAYER 4
Black-and-white
conversion

*Tips

When you want to work on a
specific layer, you have to first
click and highlight the relevant
layer in the Layers palette. If you
don't, you will be adjusting or
working on whichever layer is
currently selected.

If you switch off a layer's
visiblilty using its eye icon, you
are prevented from adjusting
the layer in any way – it has
effectively become invisible to
the program.

Adjusting layer opacity

Adjusting the *Opacity* slider at the
top of the Layers palette makes the
selected layer semi-transparent,
allowing more of the layer below to
show through. The lower the opacity
of a layer, the more you will see of
the layer below. This is a key feature
of image manipulation in Photoshop.

**The two images below demonstrate
the effect of an Opacity adjustment
and how switching a layer off reveals
the layer below.**

**Here, the black-and-white layer on
top is merging with the Dry Brush
layer directly below it.**

**When the Dry Brush layer, second
from the top, is switched off, the top
layer now merges through to the
high-contrast image.**

Blending modes

You can make the top layer in the Layers palette affect the layer beneath it without adjusting its opacity by changing the Blending mode.

The technique is very simple – just click on the drop-down window at the top left of the Layers palette (*Normal* is selected by default), and choose between the different modes.

Predicting the effect each blending mode will have is difficult, and depends on the nature of your image. It will take time to master, but it's well worth experimenting when you have plenty of time on your hands!

There are a few basic blending modes you should be aware of straight away, as shown in the samples below.

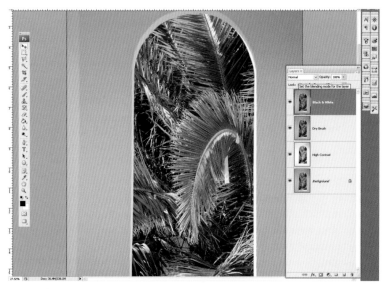

Normal has no effect on the layer beneath.

Multiply has a pronounced effect on the darker pixels in an image.

Screen has a pronounced effect on the lighter pixels in an image.

Luminosity is ideal for blending a black-and-white layer with a colour layer, as it only affects the luminance.

Creating a Blank Layer

When you start retouching images, it is best practice to work on a new layer to avoid affecting the original image. To do this, you will need to create a blank layer above the original layer. On the Layers palette, click the icon next to the Trash Can – this is the *Make New Layer* icon. It's as simple as that.

In the example below, a new blank layer was created to clone the cactus. Creating a new layer, rather than simply duplicating the Background layer, allows the cactus to be moved, resized and repositioned while keeping the Background the same. To create several different-sized cacti, I made a new blank layer for each.

Tip
Save your layered files in PSD format, as this will not flatten your image. All your layers will be retained for later use.

Copying and pasting

When you select part of an image, and copy it (*Edit > Copy* or Ctrl/Cmd+C) and paste it (*Edit > Paste* or Ctrl/Cmd+V), a new layer will appear automatically, with the selection showing in the layer thumbnail.

Selecting and dragging layers

Each layer can be moved around independently within the image area. To move a layer, select the Move tool (V) from the Tool Bar, click on the layer you want to move in the Layers palette, and then click on the image and move the layer as desired. You can even drag a layer from one image onto a different image.

At the top of the Tool Options Bar is a feature called *Auto-Select*. The drop-down menu can be set to *Layer* or *Group* (for grouped layers). When the *Auto-Select* option is checked, any layer or group of layers you click on in the image instantly becomes your working layer. This can save you from having to select the relevant layer from the Layers palette each time, though it can become problematic if your layers are very close together in the image. With *Auto-Select* switched on, you can also right-click the mouse to display the layers close to the cursor.

LAYERS – ADVANCED

Creating a Text Layer

To add text to an image, select the Text Tool from the Tool Bar (shortcut T) and click on the area of your image where you want to add the text. A new text layer will automatically be created in the Layers palette.

To edit the text, double-click the text layer icon in the Layers palette, identified by a capital T, and instantly all of the text on that layer is highlighted. You can then edit or replace the text, or change its colour and other attributes, just as you would with a word-processing program.

Layer Styles

Each layer can have effects, or styles, applied by double-clicking the layer's thumbnail in the Layers palette. The *Layer Style* dialog box will appear, which enables you to change the Blending Options, apply a drop shadow, add a key line and many other effects. Text layers can also have effects applied, but you have to double-click around the layer name and not on the thumbnail.

***Tip**
The *Layer Style* dialog box can also be accessed by clicking on the fx icon at the bottom of the Layers palette.

Here, a stroke line and drop shadow have been applied to the inset layer on this image using the Layer Style dialog box.

Adjustment layers

Adjustment layers allow you to affect all or some of the layers in your image with a fully editable, non-destructive layer. 'Non-destructive' means that all the original pixel information remains in the file, so that you can return to and re-edit the layer at a later date. Click on the *Create new fill or adjustment layer* icon at the bottom of the Layers palette and you will see various options in the drop-down menu, including *Levels*, *Curves*, *Black & White* and even *Photo Filters* – as used in the shot below, where a sepia filter has been added.

Just like other layers, adjustment layers only affect the layers beneath them. That's why in this image the *Black & White*, *Levels* and *Photo Filter* layers only affect the bottom layer, unlike the *Levels* adjustment layer at the top, which affects all of the layers. Each of these adjustment layers can be switched on and off or edited without affecting the original image information.

Adding a Black & White adjustment layer.

Adding a Levels adjustment layer.

The Photo Filter adjustment layer has added a sepia tone to the Black & White layer beneath it.

The final image.

MAKING SELECTIONS

Selecting a section of an image and cutting it out or adjusting its colour or contrast is something you will do almost every time you use Photoshop, and even though this is a key skill, it is in the Advanced Corrections section as it's not always as simple as it looks – especially when you are trying to cut out fine detail.

Simple Selections

The simplest selection method is *Select > All*, which has the keyboard shortcut Ctrl/Cmd+A. This selects the whole image or the whole of the selected layer. Once you have made a selection, you can copy it using *Edit > Copy* or Ctrl/Cmd+C and paste it using *Edit > Paste* or Ctrl/Cmd+V.

However, the Select menu offers far more than just simple commands like *Select > All*. You can also invert a selection and refine and add to your selection, so take time to familarize yourself with this menu.

As well as the *Copy* and *Paste* functions, the Edit menu contains the *Transform* and *Align* functions, but these commands only come into play after you have made your selection.

Selection Tools

There are several powerful tools on Photoshop's Tool Bar to help the job of making selections easier.

Marquee Tool
Keyboard shortcut: M

The Rectangular and Elliptical Marquee Tools operate by simply clicking and dragging the cursor around the desired area. The area you select is then shown by 'marching ants' – a dotted line that revolves around the selection. To move the selection, keep the Marquee Tool selected rather than using the Move Tool. The Move Tool will 'pick up' the selected area of the image rather than just moving the marching ants. However, if you want to drag a selection from one image to another, use the Move Tool to drag it between windows.

Feathered selections

Both the Elliptical and Rectangular Marquee Tools can be used with a soft edge called a feather, which is very useful if you want your selection to blend seamlessly onto another background. To feather your selection, enter a value (measured in pixels) in the *Feather* box on the Tool Options Bar.

This technique can also be used if the selection is inverted (*Select > Inverse* or Shift+Ctrl/Cmd+I). In the image below, I selected the flower with the Elliptical Marquee, inverted the selection and deleted the background from the image. Because the *Background Color* on the Tool Bar was set to black, the background was filled with black. Notice how the feathered selection has a soft transition towards the black, while the unfeathered selection is a hard-edged cutout.

Feathered selection

Unfeathered selection

Refine Edges

The *Refine Edges* option on the Tool Options Bar was introduced in Photoshop CS3, and allows you far greater accuracy in adjusting your selection before you apply it. This includes several modes to help you see and manipulate your selection area, with a live preview as you make your changes. The palette is quite user-friendly and also offers hints at the bottom as you go along.

The tools used to change the selection are easy to use, and are used either independently or together to change the selection's edges. The *Radius* control helps with fine edge detail, and, combined with a slight feather, produces a softer selection. The *Contract/Expand* slider is useful especially when you are cutting out of white, as a slight contraction removes any white edges in the selection.

The *Refine Edges* controls are mainly used when you are making a manual selection around an item, and are less useful with tools such as the Marquee that give a predefined shape.

Lasso Tools
Keyboard shortcut: L

There are three Lasso selection tools. The first is the basic freehand Lasso tool that allows you to draw around any shape by hand to select it. The second is the Polygonal Lasso, which involves clicking the mouse at different points surrounding the area you want to select, and the tool joining the dots between them. This is quite an accurate selection method, but a pen and graphics tablet are recommended if you plan to use it regularly, as you may soon get tired of clicking the mouse numerous times around an image instead of just pressing the nib of the pen on to the tablet. Finally, the Magic Lasso Tool is just that – magic. It grabs onto the defined edges of your selection and generally works very well unless the selection area contains similar tones of colour or contrast.

Quick Selection Tool
Keyboard shortcut: W

This tool was new to Photoshop CS3 and makes light work of selecting areas with a variety of tone and colour. To use the tool, press W or select it from the Tool Bar, then drag the cursor over the parts of the image you want to select. Unlike the Magic Wand (see page 93) you don't have to press and hold the Shift key to add to the selection.

*****Tips**

When making selections, it is often easier to select the background rather than the subject and then invert the selection using *Select > Inverse* or the keyboard shortcut Shift+Ctrl/Cmd+I.

To remove a part of a selection, press the Alt key and click. To add to a selection, press the Shift key and click. Any selection tool can be used to add to or subtract from a selection.

Photoshop allows you to save your selections within the image. Go to *Select > Save Selection* to save a selection. To reapply the selection, go to *Select > Load Selection*.

Magic Wand
Keyboard shortcut: W

The Magic Wand is a fantastic tool that measures the pixels in an image; when you click it, it selects all the nearby pixels that are similar in tone and colour based on the *Tolerance* you set on the Tool Options Bar. When you set the Tolerance, you set the number of colour shades the tool will select based on the initial pixel. To add to a selection, press and hold the Shift key, then click again to gradually build up the selection. If the image has a solid background, use the Magic Wand with a low Tolerance to almost instantly select all of the background.

1 Here, I clicked on the sky with the Magic Wand Tool with a Tolerance of 10. This selected the whole background. When making a selection like this, if any small areas are left out, you can either Shift+click the relevant area or go to *Select > Similar* from the main menu. In this case, that might include the gaps between the tree leaves that were not selected because they were enclosed by a darker area.

2 To check which areas of the image are selected, enter Quick Mask mode by clicking the circle-within-a-rectangle icon that is second from the bottom on the Tool Bar. Everything shown in red is protected. (See pages 94–5 for more on using masks.)

3 Finally, I inverted the selection (*Select > Inverse* or Shift+Ctrl/Cmd+I) so that the cacti were selected instead of the sky. The selection was then ready to be copied and pasted to another layer or moved to another image. In this instance, I dragged an image of a different sky on to a layer below the pasted leaves.

4 Above and right, you can see the difference between a selection with refined edges and the same selection without. Without using the *Refine Edges* tool, the selection still contains some of the white sky; the refined edges give the image a much more seamless look.

Left: Without refined edges
Above: With refined edges

MASKS

Selections and masks are both designed to protect or isolate certain parts of an image while allowing any changes applied to affect the unselected or unmasked areas. Most photographers tend to use either the selection method or the masking method, depending on their skill level and working preference.

Quick Mask Mode

There are several ways to make a mask to protect a section of the image. The simplest is the Quick Mask Mode, which is accessed from the circle-within-a-rectangle icon at the bottom of the Tool Bar. If you have created a selection already, when you switch on this mode your marching ants will disappear, and then reappear when you click the icon again to go back to Standard Mode.

Selection in Standard Mode

Selection in Quick Mask Mode

1 To make a selection in Quick Mask Mode, select the Brush Tool from the Tool Bar (shortcut B), and paint over the areas you want to protect. These areas are shown in a red, semi-transparent colour. To add new areas, just keep painting, changing brush sizes using the left and right square-bracket keys to increase or decrease the size of the brush.

2 When you return to Standard Mode you will see that the area you painted has been selected, and is surrounded by marching ants.

3 If you want to erase part of the mask and change your selection, return to Quick Mask Mode, and set the Foreground Color to white by clicking on the double-ended arrow next to the Set Foreground Color icon. Paint over the sections you want to remove and the red colour will disappear.

4 Use the Opacity option on the Tool Options Bar to adjust the level of protection you are applying to the area. Then go back to Standard Mode to see your new selection.

ayer Mask Mode

nother way to create a mask is by using layers.

First, duplicate the Background layer by going to *Layer > Duplicate er.* Then, to create a Layer Mask, either click the *Add Layer Mask* icon on Layers palette or go to *Layer > Layer Mask > Reveal All.* Both of these thods will result in a Layer Mask thumbnail appearing next to the layer mbnail in the Layers palette.

2 In this example, I have converted the top layer to black and white to demonstrate the effect of the Layer Mask. Click on the Layer Mask thumbnail in the Layers palette. Select the Brush tool and paint black onto the image; as you do so, your brush strokes will reveal the layer underneath – in this case the colour layer. The white Layer Mask you created hides all of the layer beneath until you reveal it by painting.

To work in the opposite way – so the layer on top is hidden fully and you eal its contents by painting – click on the Layer Mask thumbnail and n press Shift+Backspace to reveal the *Fill* dialog box. Select *Black* from Use drop-down meu and this will fill the layer mask with black, hiding layer fully. To reveal parts of this layer, paint black onto the image.

***Tip**
When using either Mask method, the foreground colour must be black to protect and white to reveal. Press D on the keyboard to reset the colours and X to switch their places. If you select any another colours, they will appear as tones of grey.

LENS CORRECTION FILTER

Some common image problems – such as wide-angle distortion and dark edges on an imag known as vignetting – are caused by flaws in camera lenses, and can be fixed using the Lens Correction Filter. However, this filter can also be used in reverse for creative effect.

Vignettes

A vignette – a dark edge around the image, often caused by the lens or lens hood – can be easily removed using the Lens Correction filter (*Filter > Distort > Lens Correction*). However, a vignette effect is often deliberately added to an image for extra impact – to draw the viewer's eye in towards a particular place on the canvas. Here, we'll see how to apply vignette effects to portraits.

Original image

Adding a vignette

The easiest way to add a high-key (light) or low-key (dark) vignette in Photoshop is to use the Lens Correction filter. We'll use the Lens Correction technique on this portrait.

1 Choose an image and open it in Photoshop. From the main menu, select *Filter > Distort > Lens Correction*.

2 In the resulting dialog box, the fourth slider down is the Vignette adjustment. Move the slider to the left to add a dark vignette – perfect for a mid- to low-key image like this one.

3 The corners of the image are darkened, drawing your eye into the image. When you're happy with the result, click *OK* to leave the Lens Correction screen and return to the main Photoshop window.

oft-focus vignettes

Another effective vignette style is to soften or blur the edges of the subject, as you can see in this portrait. This, too, is easy to achieve in Photoshop.

Original image

1 To add a soft-focus vignette to an image, first select the Elliptical Marquee Tool (shortcut M) from the Tool Bar. In the Tool Options Bar, add a 155-pixel feather – this will soften the edges of the selection.

2 Using the Elliptical Marquee Tool, drag a vertical ellipse around the subject. Then invert the selection by going to *Select > Inverse* from the main menu bar, so that the changes affect the outer area and not the girl's face.

3 To add a blur to the outer edges, apply the Gaussian Blur filter by selecting *Filter > Blur > Gaussian Blur* from the main menu. Alter the amount of blur you add by adjusting the slider; you will see a live preview on screen, so no guesswork is required.

4 Finally, deselect the selection (*Select > Deselect* or Ctrl/Cmd+D) and sit back and admire your results. If the blur has a very hard edge, you have forgotten to add the feather to the selection before adding the Blur filter. If the transition from blur to no blur is not wide enough, try reducing the feather of the Marquee selection first, as this all depends on the size of your original image.

Chromatic Aberration

Chromatic aberration is also known as colour fringing and is the result of misaligned pixels causing coloured bands along the lines in an image. This problem is common with low-spec digital cameras and lenses, but can be fixed with Photoshop's Lens Correction filter.

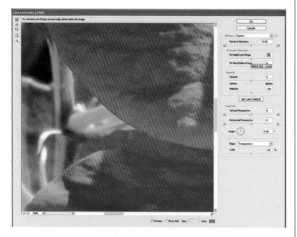

1 First, select *Filter > Distort > Lens Correction* from the main menu, and in the resulting dialog box, look at the *Chromatic Aberration* sliders towards the top of the panel. In this image, you can see that the visible ghosting on the edges is red. The opposite colour needs to be applied to fix the problem, so in this case we need to adjust the Cyan.

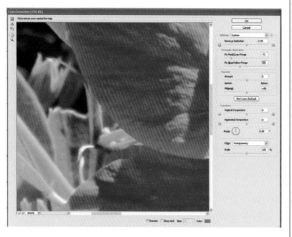

2 With the Preview window switched on and the Grid switched off, it is easy to adjust the slider and watch the colour fringing disappear.

Lens Distortion

If you have used a very wide-angle lens close up on a subject, even Photoshop's Lens Correction filter cannot get rid of the fish-eye distortion. However, it can reduce the effect – or exaggerate it! Open the Lens Correction filter (*Filter > Distort > Lens Correction*) and adjust the *Remove Distortion* slider until you achieve the desired effect.

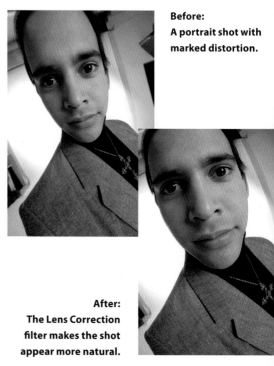

Before:
A portrait shot with marked distortion.

After:
The Lens Correction filter makes the shot appear more natural.

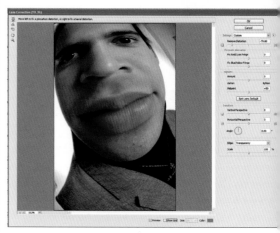

Drag the Remove Distortion slider to the left or right to alter the effect – but don't overdo it!

Perspective Correction

Vertical or horizontal perspectives that aren't straight are simple to correct in Photoshop, again using *Filter > Distort > Lens Correction*. Here, I will use the *Vertical Perspective slider* in the *Transform* section of the Lens Correction dialog to correct the vertical.

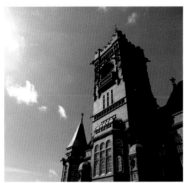

Original image

1 First, I increased the canvas size by adding 2in (5cm) of blank canvas to the top of the image. This was to allow the weathervane to remain in view once the image had been stretched to correct the perspective. This is a common problem with this type of correction, and the command does not increase the canvas size automatically, so get into the habit of adding some extra canvas before going to the Filter menu.

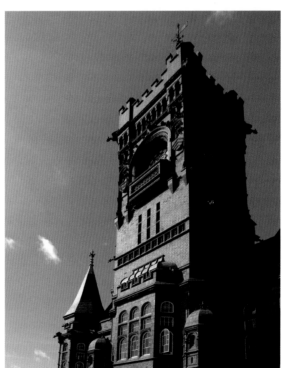

After perspective correction

2 Go to *Filter > Distort > Lens Correction* and adjust the *Vertical perspective* slider. For this image, the slider has moved into to the negative to compensate for my camera looking upwards.

3 Now the verticals in the image have been corrected, recrop the image to remove the unwanted blank canvas at the bottom of the page.

FILTER EFFECTS

The range of filter effects available in Photoshop seems endless, especially when you learn to use several of them together to produce completely different results. Smart Filters, introduced in CS3, now allow you to use filters non-destructively – meaning that you can return to an image and fine-tune your effects at any time.

The Filter Menu

You won't need any encouragement from me to delve into the Filter menu and see the effect each filter has on an image. But what are filters really for? Well, besides helping to make a silk purse out of a sow's ear, they are very powerful tools for retouching and creative image manipulation, affecting either the whole image, selections or specific layers. Many of the 'quick fix' actions you will see for sale are just different ways of blending different filters together to create a particular effect.

The Filter drop-down menu is split into five sections. The first section, *Last Filter*, allows you to instantly reapply the last filter you used in your current Photoshop session. You can also use the keyboard shortcut Ctrl/Cmd+F to do this.

The second section is *Convert for Smart Filters*. This was new in CS3 and allows the filter to be fully editable – in other words, it is non-destructive to the image and can be adjusted at a later date.

The third section is for making advanced edits to your images. We have already looked at the *Liquify* tool (see pages 68-69). The *Filter Gallery* is a great way to familiarize yourself with Photoshop's huge array of effect as it offers large Preview windows showing precisely how each filter will work on your chosen image. The *Extract* dialog box is very good for cutting out selections.

The fourth section is the good stuff, and could keep you busy for days – so if you really want to learn Photoshop in a weekend, be careful! On the next three pages we will look at a few of the most useful filters in more detail, but you can experiment with the others at your leisure.

Finally, any third-party plug-in filters that you have bought appear at the bottom of the Filter menu. I have some Nik filters installed, and I also use Genuine Fractal Mask Pro and Photo Frame Pro – but these are far from essential when you're first starting out.

Photoshop's Filter menu: you could easily spend a whole weekend just on this menu, so be careful!

n original image with no filters applied.

The original image with a Dry Brush filter applied.

he same image with a selective blur applied.

The same image with both a Dry Brush filter and Diffuse Glow applied to create a new effect.

Dry Brush
Filter > Artistic > Dry Brush

This filter can add a touch of Monet to a scene, as the dappled look is reminiscent of Impressionism. *Brush Size* determines the size of the blobs of colour, *Brush Detail* sets how much of the original detail is visible, and *Texture* determines the fuzziness of the edge detail.

Motion Blur
Filter > Blur > Motion Blur

Motion Blur does exactly way you'd expect. It is another of my favourite Blur filters, and is very flexible. The blur can be pointed in any direction using the *Angle* control.

Gaussian Blur
Filter > Blur > Gaussian Blur

This filter can simulate depth of field blur, so it can be used effectively on a wide variety of images – especially when you then use the *Erase to History* option to bring back some of the detail.

Diffuse Glow
Filter > Distort > Diffuse Glow

Diffuse Glow is ideal for landscapes and portraits. Depending on the *Glow Amount* and the *Graininess*, it produces a very soft, pointillist image, and is a great over-the-top softener.

Noise
Filter > Noise > Add Noise

This filter can be used to add a grain effect – not quite as good as film grain, but near enough. When using this filter, tick the *Monochromatic* box and use the *Gaussian* distribution – it's far better than the uniform effect.

Lens Flare
Filter > Render > Lens Flare

I am a fan of lens flare in the right circumstances, especially if I can use it to hide or disguise a problem in the image. To use the filter, drag the cursor in the Lens Flare window around to set the light source position and then decide how strong you want the effect to be.

Tip

Third-party plug-ins, such as Nik Filters, offer some amazing editable effects – nothing that you could not achieve in Photoshop, but you would have to be very proficient and have a lot of spare time to match some of the third-party effects.

BLACK & WHITE CONVERSIONS

Converting a colour image to black and white couldn't be easier. As with most effects in Photoshop, there are several ways to achieve it and some techniques will produce better results than others, depending on the original image and the desired effect. But with the advanced black-and-white conversion techniques introduced in CS3, you will probably never need to look anywhere else.

Basic Grayscale method
Image > Mode > Grayscale

Converting an image to greyscale might seem like an easy option for switching from colour to mono, but you will lose detail and, more importantly, the colour information channels which you can use to control the desired mono effect. For greater creative control, use one of the other methods described below – unless you are using the image on the web, as the file size will be greatly reduced by using the basic greyscale technique. If you use this method, you may wish to adjust the contrast by going to *Image > Adjustments > Brightness/Contrast*.

Tip
*
Avoid converting your images to mono using the Grayscale mode, as this prevents you from using some of the *Black & White* options in the *Image > Adjustments* menu. A greyscale image contains no colour channels; to add colour tone to a greyscale image, you need to convert it back to RGB using *Image > Mode > RGB Color*.

Channel Mixer method
Image > Adjustments > Channel Mixer

My favourite way to obtain a black-and-white image is to use the Channel Mixer adjustment in Photoshop. The Channel Mixer technique is the closest to a traditional monotone photograph, allowing me to adjust its tone and contrast within the channel mixer conversion itself.

1 Go to *Image > Adjustments > Channel Mixer*.

2 Check the *Monochrome* box to work in mono.

3 Adjust the *Red*, *Green* and *Blue* sliders until you achieve the desired result. For this image, I moved the *Red* slider to +78 and the *Green* slider to +22. The *Blue* channel was left at 0 because the values of the three channels always add up to exactly 100.

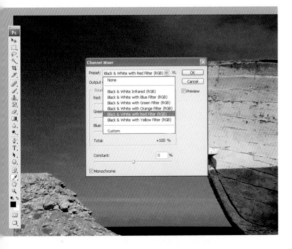

4 Photoshop CS3 now has automated settings to simulate camera filters associated with black-and-white photography, such as a red filter to whiten skin and darken skies. If you can't find the effect you want by changing the settings manually, use one of these as a starting point. When you find a black-and-white look you like, save it as a Preset by clicking on the box next to the *Preset* menu and giving your settings a name.

***Tips**

When using the Channel Mixer, always make a new adjustment layer by clicking on the *Create new fill or adjustment layer* icon in the Layers palette. This will create a fully editable Channel Mixer layer, and by double-clicking on the layer icon in the Layers palette, the Channel Mixer dialog box will be launched for readjustment. This can also be dragged onto other images to apply the same effect, and the technique is non-destructive until the image is flattened.

For an overexposed or very high-key image, try entering values of Red +50, Blue +25, Green +25 in the Channel Mixer dialog. This setting will reveal more detail in the highlight areas.

Photoshop Black & White method
Image > Adjustments > Black & White
Keyboard shortcut:
Alt+Shift+Ctrl/Cmd+B

The Black & White feature was new to Photoshop CS3, and introduced a large array of practical standard filters that dramatically change the look of an image when it is converted to black and white. These Black & White filters are based on camera filters associated with monochromatic effects and are accessed via *Image > Adjustments > Black & White* or the keyboard shortcut Alt+Shift+Ctrl/Cmd+B.

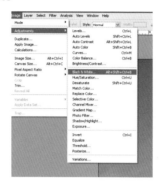
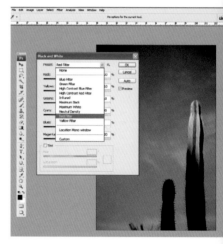

Black & White for landscapes

In the old days of film, using coloured filters to change the tonality of an image was an essential art to learn – using a red filter to darken blue skies or a blue filter to lighten blue skies, as well as change the other elements in the image with the same colour, slightly or dramatically shifting the relevant tones.

Now, using Photoshop's Black & White feature, this image of a cactus can be dramatically changed with little or no technical skill required. First, go to *Image > Adjustments > Black & White* or use the keyboard shortcut Alt+Shift+Ctrl/Cmd+B. Then select each filter in turn from the drop-down menu.

The original image was shot under the midday sun, so the light was very harsh, exaggerating the texture of the cactus. The exposure is dense due to the strong sun lighting the plant and the sky behind.

The Blue Filter lightens skies and the overall deep tones in an image.

The High Contrast Blue Filter whitens the blues, lifting the overall tone of the image.

The Green Filter gives a neutral tone and an effect midway between those of the Red and Blue Filters.

Maximum White will lift the key of the image, making it lighter with more light-grey tones.

Maximum Black will lower the key of the image, making it darker overall.

The Red Filter darkens skies.

The High Contrast Red Filter dramatically darkens blue skies.

Infrared makes skies very black and increases contrast.

Yellow creates an effect similar to Red but with more tone in the highlights.

Neutral Density flattens the image to a midtone.

Custom settings

The Black & White dialog also lets you set your own adjustments and save them for later use. To set your custom look, first select one of the conversion looks that most suits the image, then select *Custom* from the *Preset* menu. At this stage, the settings will remain the same.

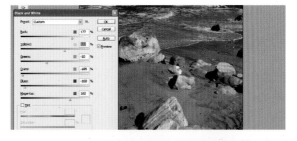

Next, select the areas you want to adjust using the eyedropper tool that appears on the image as your cursor leaves the dialog box. When you select a point on the image, the relevant colour is highlighted on the sliders. Adjust that slider as required and follow the same procedure for the other areas you want to change.

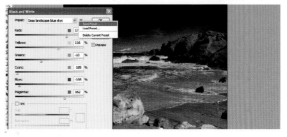

Save your Custom look by clicking on the icon to the right of the *Preset* drop-down menu window and selecting *Save*. Name and describe the look for future reference.

Black & White for Portraits

Black-and-white portraits are always popular, but as you will see from the following examples, the preset looks in the Black & White filter are not always ideal. Create your own custom Presets instead, using the method described on page 107. A stronger look can be applied to studio sessions, but location portraits will either be lit by flash, sun, or reflector, so you will probably need a slightly different effect for each.

The original image was shot using a soft lighting setup for better skin tone, by setting up a key light fitted with a softbox to f8 and a fill light set to f5.6. When the Black & White filters are applied, the image looks completely different in tone. Red, yellow and orange filters are always the best option for portraits because they lighten the skin, covering up blemishes.

The Blue Filter lightens the image, makes white skin grey and shows up spots and facial flaws. Not recommended!

The High Contrast Blue Filter makes skin tone detail look even worse than the Blue Filter.

The Green Filter gives a neutral effect midway in tone between the Red and Blue filters.

Maximum White will lift the key of the image, making it lighter with more light-grey tones.

Maximum Black will lower the key of the image, making it darker with more black.

The Red Filter whitens skin tones.

The High Contrast Red Filter washes out white skin tones.

Infrared increases the appearance of veins on the skin.

The Yellow Filter has a similar effect to the Red Filter but with a little more tone in the highlights.

Neutral Density lightens skin tones across the image.

Black and white in RAW

If you are working with RAW images and want to convert them to black and white at the RAW stage, open the RAW image in Adobe Camera RAW via Bridge and reduce the Saturation slider fully. Notice that the Temperature slider now adjusts the grey tone slightly instead of the colour. Adjust your image accordingly with the Contrast, Shadow and Brightness sliders.

When you're satisfied with the result, save the settings via the drop-down arrow next to the Settings dialog box and save it as Mono, or save the image and the new settings.

If you have saved the settings as a preset look, you can now apply these settings to any number of RAW images via the Bridge window. This is done by selecting the images and then right-clicking on them. In the resulting dialog box, choose the Develop settings and your saved setting will be there. Alternatively, you can of course apply the settings in the actual Camera RAW window.

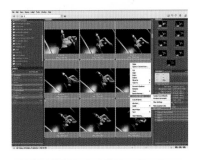

SPLIT TONING

The wet darkroom technique of split-toning a black-and-white image – in which the shadow and highlight areas have a different colour tone added, giving a slight hue to a monochrome image – now takes seconds to reproduce in the digital darkroom.

Split toning in Adobe Camera RAW

It's easy to apply a variety of split-toning effects to an image using the Adobe Camera RAW window, as we will see in the following example.

1 Open your image in Adobe Camera RAW and convert it to greyscale (this can be done to any image file; it is not dependent on shooting RAW). Click on the *HSL/Grayscale* button, fourth from the left above the sliders, and check the box marked *Convert to Grayscale*.

2 With the grayscale conversion made, you can adjust the colour sliders to change the contrast of the image tones, just as you would in Photoshop itself. When you have made the tone adjustments, go back to the *Basic* window (by pressing the first button in the row above the sliders) and adjust the *Exposure* a little, as well as the *Temperature* slider, to increase or decrease the detail.

3 Select the *Split Toning* palette by clicking on the fifth button from the left above the sliders. The palette is divided into three sections: the *Highlight* section at the top; the *Shadows* section at the bottom; and in the middle, the *Balance* slider, which is used to shift the tone colour bias to either the shadow areas or the highlight areas.

4 Adjust the *Highlights* slider. Select the hue that you would like to see in the highlight areas by sliding the *Hue* bar. At first there is no colour visible, so adjust the *Saturation* slider to make the colour visible and determine its strength.

5 Adjust the *Shadows* slider, following the same procedure as in the previous step, making sure the colour is different from the one you selected for the highlights.

6 Adjust the *Balance* slider, moving the bias of tone towards either the highlight or shadow areas. At this point, you will probably need to alter the *Saturation* sliders a little to boost the amount of colour visible.

Highlight colour

Shadow colour

Split toning with bias towards the highlight colour

Split toning with bias towards the shadow colour

Remember that it is not only the Balance slider that determines the colour bias, but also the saturation of the colour in the highlight and shadow areas, as shown in the examples below.

Highlight – Amber
Shadow – Blue
Bias – None

Highlight – Amber
Shadow – Blue
Bias – Shadow

Highlight – Amber
Shadow – Green
Bias – None

Highlight – Blue
Shadow – Purple
Bias – Shadow, with increased Saturation

Highlight – Red
Shadow – Purple
Bias – Shadow, with increased Saturation

Highlight – Red
Shadow – Purple
Bias – Highlight

***Tip**
It is essential to convert your image to greyscale when using the Split Toning palette in Adobe Camera RAW to adjust a TIFF or JPEG file.

ADVANCED CORRECTIONS

Faking a duotone in Photoshop

Duotones are traditionally printed using just two colours instead of four, and are perenially popular. Here's a quick way to fake a duotone image in Photoshop.

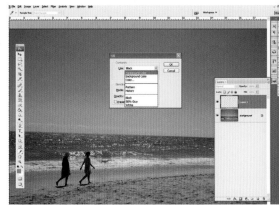

1 Open your image in Photoshop. Create a new layer by clicking on the *Create a new layer icon* in the Layers palette.

2 Select the colour you wish to use to create your duotone. Click on the *Se foreground colour* icon on the Tool Bar and choose a colour from the Color Picker that appears. Fill your new layer with the colour by either using the Paint Bucket Tool (shortcut G) or by pressing Shift+Backspace and selectin *Foreground Color* in the resulting dialog box.

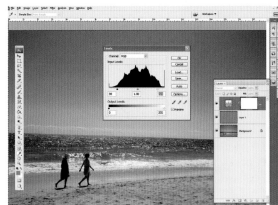

3 The image will disappear and all you will see is the colour you selected. Don't worry – to fix this, go to the Layers palette and select the *Color* blend mode from the drop-down menu at the top.

4 Finally, click on the *Create a new fill or adjustment layer* icon in the Layers palette. Add a *Levels* adjustment layer and adjust the contrast. Your duotone image is complete.

Photoshop Presets

Photoshop has its own presets for creating dutones, tritones and quadtone images. To apply these to an image, use the procedure outlined below.

Open your image in Photoshop.

2 Convert the image to greyscale by going to *Image > Mode > Greyscale*.

3 Go to *Image > Mode > Duotone* to open the Duotone Options dialog box. Select *Quadtone* from the *Type* drop-down menu.

5 The procedure is the same for any of the wide range of presets that come with Photoshop CS3. Experiment with different Presets until you find the ones you prefer.

Click *Load* and locate the Quadtone presets the *Quadtone* folder. Choose a Preset and click OK. Here, I used a Preset from the Pantone set, but you can use whichever one you like. Remember to change the image back to RGB colour mode (*Image > Mode > RGB Color*) before you save it.

This landscape has had the Duotone preset Warm Grey 11 bl2 applied.

As their name suggests, tritone images mix three colours to tone the image. To create a tritone, simply select *Tritone* from the *Type* box in the *Duotone Options* dialog box and load a preset as before.

LIGHTING AND GRADIENT EFFECTS

Photoshop gives you the opportunity to experiment with numerous creative lighting effects. Gradients are a simple but effective way to alter the lighting in your shots, while the Photo Filter offers a selection of preset effects that you can customize with your own choice of colours

Darkening skies with a Gradient layer

Gradient layers are very useful for landscape photographs. In this example, we'll use a Gradient layer to darken the sky and give this shot a moodier look.

1 First, make a new layer by clicking on the *Create a new layer* icon in the Layers palette. Then select the Gradient Tool from the Tool Bar (shortcut G).

2 In the Tool Options Bar, click on the Gradient Editor (the coloured drop-down menu second from the left) and select the *Foreground to Transparent* option. Still on the Tool Options Bar, ensure that the *Linear Gradient* option is selected (the first of the five options shown).

3 Select a dark, neutral foreground colour, such as grey, by clicking in the Foreground Color square on the Tool Bar. With the Gradient Tool, drag down a line from the top of the image to near the horizon.

4 In the Layers palette, go to the blending mode drop-down menu and select *Multiply*. Adjust the *Opacity* of the Gradient layer for a more subtle effect, and you're done.

Photo Filter

To adjust the overall tone of the lighting in an image, use Photoshop's Photo Filter. Here, I'll give these things a warm, sunny glow.

Original image

Go to *Image > Adjustments > Photo Filter* to bring up the *Photo Filter* dialog box.

2 Choose an option from the *Filter* drop-down menu or select your own colour by clicking the *Color* button and using the Color Picker. Click *OK* when you're done.

The finished image

Radial Gradients

Radial Gradients are an easy way to apply a colour or extra brightness if the foreground colour is white around the whole image. It can often be more powerful than a basic vignette effect.

To apply the effect, click on the *Create new fill or adjustment layer* icon in the Layers palette and select *Gradient* from the list. In the resulting dialog box, select *Radial* from the *Style* menu. If you want the colour to appear around the edges, as in this image, check the *Reverse* box.

2 If the *Align with layer* option is unchecked when you create the Gradient layer, you can also move the gradient off centre by adjusting the *Angle* in the *Gradient Fill* dialog box.

Radial gradient applied

Summary

■ In this chapter, we started to uncover the sheer power of Photoshop's creative image-manipulation abilities, and looked at the way you should approach working with your images to achieve the best results.

■ Making selections is one of the trickiest aspects of using Photoshop and it can take a long time to master the various techniques. Although the tools all have their own advantages, the best approach is usually to combine the different selection tools to get the perfect selection – and of course it always depends on the nature of the individual image. Refining the selection is also key to making a cutout look smooth and realistic, with no edge pixels standing out when the selection is pasted onto a darker or lighter background.

■ Layers and layer blending are what brings manipulated images alive, and as soon as you grasp the concept, anything is possible. In this chapter, you have started to learn about adding filter effects and corrections to your layers, but of course there's always more to discover and a thorough knowledge of all Photoshop's numerous filters will take much more than a weekend to acquire.

■ Finally, we learnt about how simple it is to convert a colour image to black and white, how to add tone and colour to a photograph, and scratched the surface of Photoshop's capabilities for producing creative lighting effects.

Checklist

LAYERS

- ❑ Duplicating a layer
- ❑ Creating a new layer
- ❑ Adjusting layers
- ❑ Layer blending

SELECTIONS

- ❑ Selection tools
- ❑ Making selections
- ❑ Refining selections

MASKS

- ❑ Making a basic mask
- ❑ Making a layer mask
- ❑ Using masks

VIGNETTES

- ❑ Applying a vignette

LENS CORRECTIONS

- ❑ Fixing chromatic aberrations
- ❑ Lens correction
- ❑ Lens distortion

Filter Effects

- ❑ Finding and applying filters

Black & White

- ❑ Converting colour to black and white
- ❑ Making and applying custom looks
- ❑ Split toning
- ❑ Making a duotone
- ❑ Making duotones, tritones and quadtones with Photoshop presets

Lighting Effects

- ❑ Applying a gradient
- ❑ Darkening a sky

Projects

In this chapter you will discover some quick fixes for common problems, and learn some key Photoshop techniques that you will use often and for a multitude of purposes. Adding text to an image is an important skill, especially for projects such as making photo albums or scrapbook pages. Combining images in the form of panoramas or montages is also one of the most creative processes Photoshop has to offer. And, of course, you'll want to know how to create the perfect portrait.

We've done the hard work for you by creating simple step-by-step instructions on how to achieve all this. Follow the steps carefully, and you'll get great results with your own images.

■ QUICK FIXES

■ USING TEXT

■ TEXT EFFECTS

■ WATERMARKS AND COPYRIGHT

■ CREATING A PANORAMA

■ CREATING A MONTAGE

■ USING ACTIONS

■ PERFECT PORTRAITS

■ COMBINING GROUP SHOTS

■ HIGH DYNAMIC RANGE

■ SUMMARY & CHECKLIST

QUICK FIXES

If you take a lot of photographs, there are certain adjustments that you will need to make time and time again. Here are four quick Photoshop solutions to common photographic problems. I've applied them all to the same shot so that you can easily compare the results.

Original image

Lighten a dark image

1 Open your image in Photoshop and duplicate the Background layer by dragging it onto the *Create new layer* icon in the Layers palette, or using the keyboard shortcut Ctrl/Cmd+J.

2 Change the blending mode from *Normal* to *Screen*. If the sky is still too dark, duplicate the layer again and repeat the process.

3 Change the *Opacity* of the copied layer until you achieve the desired effect. Either flatten the layers to save the image as a JPEG, or save it as a PSD to retain the layers for future adjustments.

Image lightened using Screen blending mode.

Correct verticals and horizontals

1 From the main menu, select *Filter > Distort > Lens Correction*.

2 A new window will appear showing the Lens Correction filter's controls. In the *Transform* box, use the *Vertical Perspective* and *Horizontal Perspective* sliders to correct the image.

3 Using these functions will distort the shape of your image, so crop the image accordingly with the Crop Tool (shortcut C) or use the Clone Stamp Tool (shortcut S) to retouch the missing picture elements. Save as before.

Verticals adjusted using the Lens Correction filter.

Change or fix colour

1 In the Layers palette, click on the *Create new fill or adjustment layer* icon and choose *Color Balance* from the menu.

2 Move the sliders towards Red and Yellow for a warmer image, or towards Blue and Cyan for a colder image. Click on the *Highlights*, *Midtones* and *Shadows* buttons to adjust the colours in those ranges.

3 If you want to keep the adjustment layer and return to the image later, save it as a PSD.

Warmer colours

Colder colours

Change the sky

1 Select the Magic Wand Tool (shortcut W) and click on the sky. Shift+click the main areas to select them, and then go to *Select > Similar* to add similar, smaller areas. Remove any unwanted selections by Alt+clicking. Try using the Marquee Tool or the Freehand Lasso to help select the entire sky, and refine the selection edges by going to *Select > Refine Edge*. Then go to *Select > Inverse* so that the house is selected instead of the sky.

2 Copy the selection by going to *Edit > Copy* or using the keyboard shortcut Ctrl/Cmd+C. Now paste the selection by going to *Edit > Paste* or using the keyboard shortcut Ctrl/Cmd+V. This will create a new layer in the Layers palette.

3 Open another file with the appropriate sky and drag the new sky underneath the new layer by selecting the Move Tool (shortcut V) and dragging the image onto the original image window. If the new sky is the very top layer in the Layers palette, drag it underneath the pasted selection layer.

A new sky from a different image.

USING TEXT

You will often want to add text to your images, particularly if they're destined for a scrapbook or photo album, or are to be used as part of a montage. Photoshop's Type Tool takes a bit of getting used to, but some of its basic functions will be familiar from your word-processing program.

Adding Text

1 To add text to an image, select the Type Tool from the Tool Bar or press T on the keyboard. The Type Tool has four options: the default is the Horizontal Type Tool, but you can change to the Vertical Type Tool or the Vertical or Horizontal Type Mask Tools by clicking and holding the little arrow on the Type Tool icon.

2 Select the area on the image where you would like the text to appear, then click the mouse to set the location and start typing.

3 You can change the font by clicking on the drop-down menu on the Tool Options Bar. Other options include type size, style, alignment on the page, and Warp styles to change the shape of the text.

4 By default, the text colour is set to your current foreground colour, as shown by Foreground Color icon on the Tool Bar. You can change the font colour by clicking on the *Set the text color* icon on the Tool Options Bar.

5 When you have finished typing, either press the Enter key or select the Move Tool to move out of the typing mode. Your text will automatically be saved as a new layer in the Layers palette, and you can move this layer independently with the Move Tool.

6 To edit your text, highlight the text layer in the Layers palette and then select the Type Tool. You can then edit the text in the same way as you would with a word processor.

7 You can add extra lines to your text layer by pressing the Enter key. However if you would like to add extra lines or sections of text that can be edited separately, you will need to put the new text on another layer. Select the Type Tool again and choose another location on the image. When you click the mouse, a new text layer is created and you can proceed as before.

8 When you save the image, it is wise to save the file first as a PSD, so that the text will remain fully editable. Only flatten the image by going to *Layer > Flatten Image* when you are sure the text is correct.

*** Tip**
To exit the Type Tool at any time, press the Escape key.

TEXT EFFECTS

Once you have added type to an image, you can modify and transform it in an almost infinite number of ways. If you're using your images for professional purposes, choose one or two fonts and effects that you like and keep your text style consistent. Otherwise, go crazy!

Warp Effects

To add a warp effect to your text, first insert the text as described on pages 122-123. Then, click on the *Create warped text* icon on the Tool Options Bar. In the dialog box, choose an effect from the *Style* drop-down menu and adjust the sliders until you achieve the desired result.

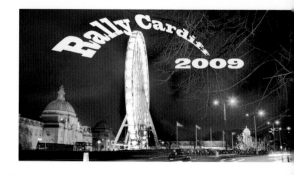

Layer Styles Options

To add an effect like a Drop Shadow or Outer Glow, click on the *fx* icon at the bottom of the Layers palette and choose an option from the pop-up menu. There are many great effects here, so play with them at your leisure. For now we'll just take a look at the two I mentioned earlier – Drop Shadow and Outer Glow.

1 First, apply a Drop Shadow by selecting *Drop Shadow* from the *fx* menu at the bottom of the Layers palette. You can either drag the shadow with the mouse on the image itself, or use the sliders in the dialog box to change the overall look of the shadow, especially the *Opacity*, *Direction* and *Distance*.

2 Next, apply an Outer Glow effect by selecting *Outer Glow* from the *fx* menu at the bottom of the Layers palette. Select the colour you want, adjust the *Opacity*, then play with the *Noise*, *Spread* and *Size* sliders as well as the blending mode to change the effects.

Horizontal Type Mask Tool

The Horizontal Type Mask Tool is ideal for copying texture from another image into your text, or if you want to cut out the type from the image to reveal the layer below.

1 Choose another image that you want to use as the texture for your text. Select the Horizontal Type Mask Tool from the Tool Bar and type your text. The screen will become a quick mask, which is why there is a reddish tint overlaying your image.

2 Click on the Move Tool in the Tool Bar to deselect the Type Tool, leaving just the outline of the text on the image.

3 Press Ctrl/Cmd+C to copy the selection. Go back to your main image and paste in the selection by pressing Ctrl/Cmd+V. Move the pasted text to its correct position. Note that the text is now an image layer, so you can no longer edit it with the Type Tool.

4 To add a Motion Blur effect to this layer, duplicate the layer by pressing Ctrl/Cmd+J on your keyboard or dragging the layer to the *Create a new layer* icon on the Layers palette. This will add the layer above the original and add 'copy' to its name, so now select the original layer below by clicking on it. Go to the main menu and select *Filter > Blur > Motion Blur*. Adjust the *Angle* and *Distance* of the blur and click *OK*.

5 When you return to the image window you will see the full effect. To add a little more impact to the image, I have moved the copy layer down a little with the Move Tool to see more of the original white layer below, and to the side to give a 3D effect.

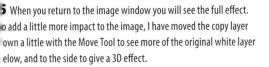

WATERMARKS AND COPYRIGHT

Copyright infringement is an increasing problem in the digital age. It's easy for people to use your work without acknowledgement, especially if you have a web gallery, so many professional photographers add watermarks to their pictures to indicate their ownership.

Adding a watermark

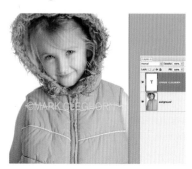

1 To add a watermark, first add the required text to your image. Select the Type Tool, click on the image and type. The copyright symbol can be obtained by pressing Alt+0 1 6 9 on the numeric keypad on the right of your keyboard (or Alt+G on a Mac). Select the font, size and colour from the Tool Options Bar, but remember to double-click the type layer's thumbnail first on the Layers palette to select all the text.

2 Choose the opacity of the text that you require – this will make it more or less prominent in the finished image.

3 Adding a drop shadow often makes text stand out more. To add a drop shadow, select the *fx* icon on the Layers palette and select *Drop Shadow* from the pop-up menu. In the dialog box, adjust the settings until you achieve the desired result.

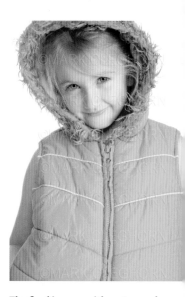

4 When you're happy with your text, duplicate the text layer by pressing Ctrl/Cmd+J and move it around the page. Duplicate the layer as many times as you like to cover the whole image.

5 Now select all the text layers and merge them together by going to *Layer > Merge Layers*. All of the text is now a single layer, and even though you have lost the ability to change the type without starting over, you can now edit the opacity of all the text at the same time, as well as changing its colour or converting it to mono.

The final image, with watermark added and converted to mono.

Warping and washing

Warping is a good way to soften the effect of ny text on the image. When you've typed your xt, click on the *Create warped text* icon on the ol Options Bar and select your preferred style.

To change to a watermark wash, simply ange the opacity of the text layer in the yers palette.

Using The Shape Tool

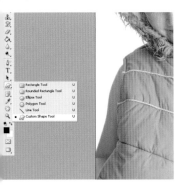

You can also add the copyright symbol using e Custom Shape Tool. First, open your image nd create a new layer. Select the Custom hape Tool from the Tool Bar (it's located in pull-out menu under the Rectangle Tool, or se the keyboard shortcut U), and change the oreground Color to grey.

2 On the Tool Options bar, click the *Fill Pixels* icon (the last in a group of three on the left of the Tool Options Bar) and select the copyright symbol from the palette.

3 Drag the shape over your image to the desired size, pressing the Shift key to keep the symbol in proportion. From the *fx* menu in the Layers palette, select *Bevel & Emboss* to give the symbol a three-dimensional appearance.

To make the symbol less intrusive, change he layer's opacity to around 20% by adjusting he slider on the Layers palette.

✱ Tip

Your copyright and watermark layers can be dragged onto other images or moved around within an image. Try making your watermarks into an Action so they can be applied instantly to other images (see pages 134-137 for more on Actions).

CREATING A PANORAMA

Stitching images together to make panoramic shots has never been easier, especially using the Auto Blend options in Photoshop CS3. When shooting for panoramas, remember to overlap your shots and keep the size of the subject fairly consistent within the frame.

The trend towards stitching together multiple shots of the same scene to make a long panorama is unlikely to fade, and the results can be impressive. There are various specialist software packages on the market to do this, but why bother when Photoshop CS3 makes it child's play?

From Bridge

1 First, select the files you wish to merge in Bridge. Here, I have chosen to create a panorama of this hotel. Why? Because I forgot my 14mm wide-angle lens on the day – but even if I'd had it, I would have had to stitch two images together to create the desired effect.

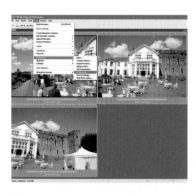 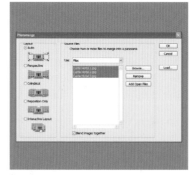

2 Go to *Tools* > *Photoshop* > *Photomerge*. Photoshop will launch automatically (if it is not already open) and the filenames will appear in the *Photomerge* dialog box.

3 Shift+click on each filename to select them all. Ensure the *Blend* dialog box at the bottom of the window is checked. Choose the *Layout* type you require – *Auto* usually does a great job – and click *OK*.

4 Photoshop works its magic and the image is now stitched and blended. The result is a three-layer file – one layer for each picture used. Photoshop also makes a layer mask for each.

5 By switching off one of the layers you can see how Photoshop has cleverly stitched the images together, with an excellent blend between the three files. Better still, it's done it in seconds.

6 Finally, the image is flattened and cropped to size. In this image I boosted the contrast using Levels (*Image > Adjustments > Levels*) and increased the saturation of the blues slightly using Hue/Saturation (*Image > Adjustments > Hue/Saturation*).

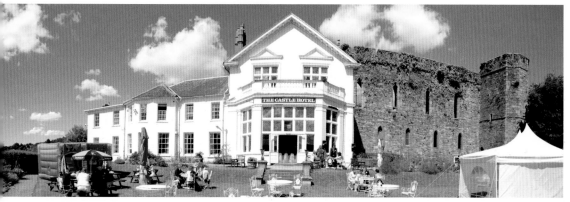

rom Photoshop

Blend option checked

Blend option unchecked

To use Photomerge directly from Photoshop, e process is very similar. First, open the files u plan to use in Photoshop and go to *File > tomate > Photomerge*.

the dialog box, click *Add Open Files*. I usually k the *Blend images together* option to allow otoshop to match up the files, and opt for *Auto* a starting point. If *Auto* does not achieve the ult you want, try one of the other options.

2 You can see the problem that Photoshop has had with lens vignetting, as the colours are darker at the edges of the frames than in the middle. This would have made blending by hand very difficult, but Photoshop has coped extremely well, with the a slight imperfection on lining up one of the horizons.

CREATING A MONTAGE

Montages can be as simple or as complicated as you like, but they basically come in two styles – page layouts, in which multiple images are arranged together on a page, but remain separate; and image-on-image montages, where multiple images are blended together to create a single image.

Page-layout or scrapbook style

The page-layout style is the simplest to achieve in Photoshop, especially if you want to align images vertically or horizontally – Photoshop's Smart Guides make light work of a mundane task.

1 Open a new document in Photoshop by going to *File > New* or pressing Ctrl/Cmd+N on the keyboard. Name your document and type in your desired image size – in this case it's 16×16in (41×41cm) at 300ppi. The Color Mode should be set to RGB, 8 bit, and I've chosen a white background for my montage.

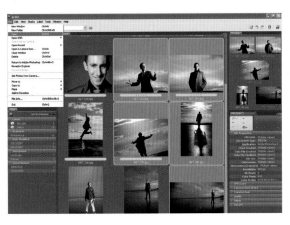

2 Open Bridge and select the images you want to use. Open them in Photoshop by either dragging them onto the Photoshop window or by pressing Ctrl/Cmd+O.

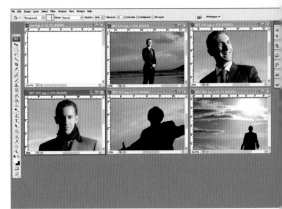

3 If one image is going to be dominant in your montage, work on that one first – the layout will be based around its shape and overall size when cropped. I usually change my desktop layout at this stage so all the images are visible at the same time. To do this, go to *Window > Arrange > Tile Horizontally*.

4 Next, with the Crop Tool selected, set a crop size for your dominant image, remembering that the resolution must be the same as the destination file (your new document), or the images will not be accurately cropped and scaled.

5 When the image is cropped, drag it onto the new montage file.

6 If you want to separate the image from the background, add a stroke line, or border. Go to *Edit > Stroke*, and choose the width, colour and whether the stroke will be inside, outside or in the middle of the image. In this case I chose a 10-pixel, black stroke line outside the image.

7 The other images should then be cropped and dragged on as desired. If you added a stroke to one, do the same for the rest to keep the image looking neat. When you are dragging the images around the page you will see the Smart Guides appear when the image is aligned with another image's top, middle or centre. These simple smart guides save me hours, as they stop me having to drag guides in from the rulers on the side and top.

The completed page layout.

Image-in-image montages

Image-in-image montages are ideal for photo album
layouts, as they allow you to maximize the space on a
page. First, set the main image to the required overall
size, and then crop and resize the additional images to
fit the page and design using the method described on
pages 130–1. In the example below, I've set a white stroke
line around the inset images to clearly distinguish them
from the main image.

A completed image-in-image montage.

Soft edges

Instead of adding a stroke line to an image, try selecting the area around the image with the Marquee Tool, then going to *Select > Refine Edge* and applying a Feather in the resulting dialog box. This will give a soft edge to the image. You can go one step further by changing the blending mode of the images to *Dissolve* – this will add a splatter effect to the image border.

A completed image-in-image montage with feathered edges and the Dissolve blending mode applied.

*Tip

When creating montages, it helps to have *Auto Select* switched on in the Move Tool options bar, as shown here, as this will automatically pick the layer you need as you click it, instead of having to go over to the Layers palette or right-clicking with the mouse.

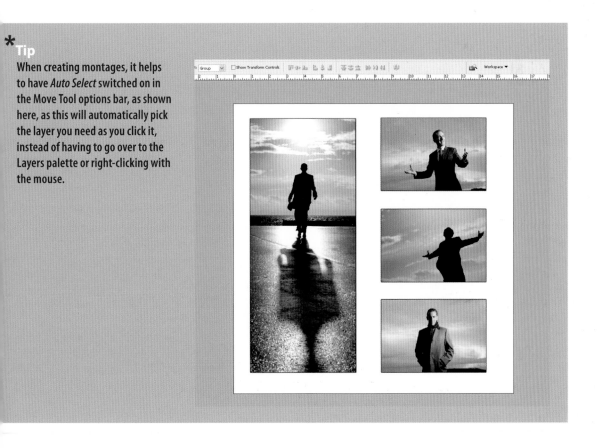

USING ACTIONS

The power of any computer is automation and that is exactly what Actions are for in Photoshop. Actions play a big role in my everyday use of Photoshop – the ability to make a recording of a series of steps, whether they are basic or complicated, makes very light work of many repetitive tasks. Remember, the more mundane the task, the more you need an Action.

The Actions palette

The Actions palette comes in two different forms – one is the Normal play and record view, and the other is Button View. Both allow you to play Actions, but only in the normal view can you record or edit an action. To change from one to the other, click on the drop-down arrow at the top right of the Actions palette and turn the Button mode on or off, signified by a tick.

The Actions palette in Normal view mode.

The Actions palette in Button View mode.

Actions can also be assigned to one of the F- (function) keys on the keyboard, which is perfect for a faster workflow. The F-key is designated at the time that you make the action and is shown at the end of its description. Each F-key has four options – the key by itself, with the Alt key, with the Ctrl/Cmd key, and with both Alt and Ctrl/Cmd together.

An Action's keyboard shortcut appears in the Actions palette along with its description.

ctions that have not been assigned a shortcut F-key can
e played in either the Normal mode by pressing the Play
utton, or in Button mode by just pressing the button.

ctions can be stored in Sets to make it easier for you
o find the correct Action, as well as making it possible
o save and reload them at a later date. This is useful if
ifferent people are using the same computer, as they
an load and save their own Actions.

**Sets of Actions can be given descriptive names so you can
easily find the Actions you need for a particular job.**

hotoshop comes supplied with a default set of Actions
s well as some special sets that can be loaded from the
ctions palette's drop-down menu. These sets can be
aunched by selecting one or all of them from this drop-
own menu, and because they are saved in the application
older you can delete them from the palette and reload
hem time after time.

**Photoshop's preset Actions are located at the bottom of
the palette's drop-down menu.**

Making a new Set

In the Actions palette drop-down menu, select *New Set*.

2 Name the Set and click *OK*. The set is empty so the toggle on or off
checkbox is unchecked – don't worry, this will automatically be ticked
when an action is made in the set.

Make a New Action

1 In the Actions palette drop-down menu, select *New Action*. Name the Action, and set an F-key if you plan to use the action often. Next, assign a colour – this makes it easy to group Actions together. Press *Record*. The red Record button at the bottom of the palette will be switched on, and every operation you then perform in Photoshop is recorded as a part of the action – including opening, closing and saving a file – so take it slowly. In this instance, I am recording an action to turn a colour image to black and white, and I have assigned the F4 key and a yellow label.

2 To create this action, go to *Image > Adjustments > Black & White* and convert your picture to black and white – remember that an identical series of operations will be performed on every image you apply the action to subsequently. Then click *OK*. Press the *Stop* button and the recording will stop; your action will appear in the Actions palette. To run your action, just press the *Play* icon at the bottom of the Actions palette.

Making a Stroke line Action

1 To make sure you've got the hang of it, let's create another simple Action. First of all, make a selection on an image using the Marquee Tool, making sure there is no Feather set in the Tool Options Bar. Now create a new Action and assign the F3 key.

2 Go to *Edit > Stroke*. Set the *Width* and *Color* and click *OK*. Now press the *Stop* button to stop. Play the Action back to make sure it has worked.

✱ Tip
Actions play back very fast, some within the blink of an eye. If you want to play back an Action at a step-by-step speed, select *Playback Options* from the drop-down menu in the Actions palette and click on *Step by Step* in the dialog box.

Linking and playing Actions

You can make an Action play another Action by selecting it as a part of the recording process. Try this – I call this Action my Hockney.

1 Open an image and select *New Action* from the drop-down menu in the Actions palette. Make a selection on the Background layer.

2 Copy the selection by pressing Ctrl/Cmd+C.

3 Paste the selection by pressing Ctrl/Cmd+V.

4 Select the Move Tool (shortcut V) and move the pasted section slightly.

5 Select the Background layer in the Layers palette and repeat the process as many times as you like, copying and pasting different areas. Make sure you always select the original Background layer before each new selection, or Photoshop will try to copy empty space.

6 Select the Background layer again and play the Black & White Action we created earlier by pressing the F4 key. Press *Stop*, and your image should look like this (depending on the image you started with!).

PERFECT PORTRAITS

The harsh realities of life can sometimes take their toll on a person's appearance – and nowhere is this more evident than in a portrait photograph. Here are some techniques that will soften and enhance your portraits and, in many cases, restore that youthful glow.

Softened Focus

This effect is a little advanced but if you follow it carefully step by step, you can use this controlled technique time after time as a starting point for softening an image and taking years off your subjects' faces. You can also make it into an Action if you wish (see pages 134–7).

This softening technique is achieved by selecting the 'Ugly' channel – better known as the Blue channel, this is where the noise in the image hides, as well as all the ugly bits, hence my expression the Ugly channel. No offence to the subject of this portrait – it's the same for everyone!

1 First, retouch the image using the Patch Tool to remove shadows under the eyes and the Healing Brush or Clone Stamp Tool for any blemishes on the skin (see pages 64–9 for more on retouching).

2 Open the Channels palette by clicking on its icon or selecting *Window > Channels* from the Main Menu. Select the Blue channel.

3 Press and hold the Ctrl/Cmd key and click on the Blue channel thumbnail. This makes a selection based on the Blue channel.

4 Open the Layers palette and create a new layer by clicking on the *Create a new layer* icon.

From the main menu, go to *Edit > Fill* and select *White* at 100%.

6 Deselect the selection by pressing Ctrl/Cmd+D on the keyboard or going to *Select > Deselect*. Now add a Gaussian blur by going to *Filter > Blur > Gaussian Blur* and entering a value of between 20 and 40, depending on your taste of softness and the size of your image.

Change the blending mode on the Layers palette to *Lighten*.

8 Reduce the *Opacity* to around 60% so that some of the original image shows through.

9 If you are making an Action, it is best to stop it here, before flattening the image, as it is still possible to erase some of the effect on the eyes and lips to keep some sharpness. This can be done with the Eraser tool.

The finished image

✳Tip

Avoid building the *Layer > Flatten Image* function into an Action, especially with this technique, as you may want to edit the individual layers again at a later date.

Brightening the eyes

A quick fix to brighten up eyes in a portrait is to use a Levels adjustment layer, created by clicking on the *Create new fill or adjustment layer* icon in the Layers palette (it's the half-moon icon).

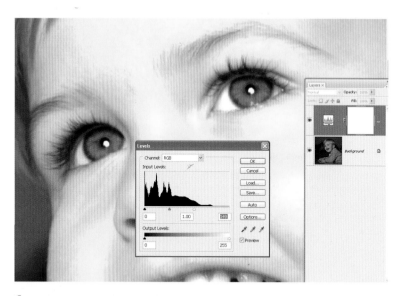

1 Click on the *Create new fill or adjustment layer* icon and select *Levels*. Move the white slider to the left until the eyes are white and bright, then click OK.

2 A layer mask will appear – it's the white rectangle to the right of the histogram on your new adjustment layer.

The finished image

3 Now invert the layer from white to black by first clicking on the layer mask and then pressing Ctrl/Cmd+ I.

4 Select a small brush and paint white into the eyes to reveal the effect of the Levels adjustment layer change. Choose a low Opacity, around 10-15, in the Tool Options Bar to gradually lighten the eyes.

Surface Blur

The Surface Blur filter is a quick fix for skin blemishes, zits and scars as well as five o'clock shadow. This technique is a love-hate thing – some people like the highly retouched look; others do not. I prefer to retain some detail in the image, especially in the hair, to maintain a realistic look. Even though this technique gets rid of most facial flaws, I like to use the Patch tool under the eyes first to take away any darkness.

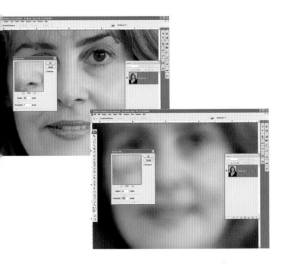

Depending on the effect you want to achieve, and the size of your image, adjust the *Radius* and *Threshold* sliders. The higher the Radius and Threshold, the more extreme the effect.

For an image of approximately 12×8in (30 x 20cm) at 300 dpi, I use a Radius of 30 or more, and a Threshold of 25 or less – this gives a strong retouched look, but hides an amazing amount of skin detail by smoothing it out.

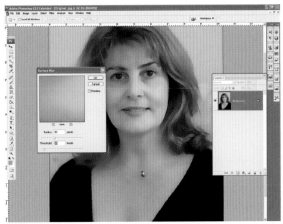

1 To apply the effect, go to *Filter > Blur > Surface Blur*. The *Surface Blur* dialog box will open.

3 When you're happy with the effect, click *OK*. Then select the Eraser Tool, and click on the *Erase to History* box on the Tool Options Bar. This allows you to put back some of the original hair detail. Alternatively, you can duplicate the layer before applying the Surface Blur; the top layer can then be erased selectively to reveal the original image below.

With no detail painted back in, the effect is too extreme.

Detail replaced using the Erase to History method.

***Tip**

When using the Eraser technique, erase a little at a time with a low-opacity brush. This technique is best done using a Wacom graphics tablet and pen.

COMBINING GROUP SHOTS

In Photoshop CS3, Adobe introduced some advanced blending options that make it really easy to blend and retouch images. The Auto-Align Layers option automatically matches up two images, enabling you to combine them or replace elements in an image quickly and easily. I use it all the time for changing the expressions of subjects or opening eyes.

Auto-Align Layers

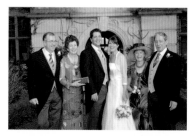

These two images will be blended so that everyone is looking straight at the camera.

1 Open the two images to be used, making sure they are similar (eg different frames from the same shoot), as this creates a far more seamless result. Drag one image on top of the other, then double-click the Background layer on the Layers palette and change its name by double-clicking on its name in the Layers palette, as at present it is locked and Photoshop will not allow you to perform the task. Shift+click to select both layers, then apply Auto-Align Layers by going to *Edit > Auto-Align Layers*.

2 Select the top layer and use the Eraser tool to rub out the relevant areas so that you can see the faces underneath. The image is done, and can now be flattened and saved. Photoshop automatically expands the canvas to allow for the alignment of the two images.

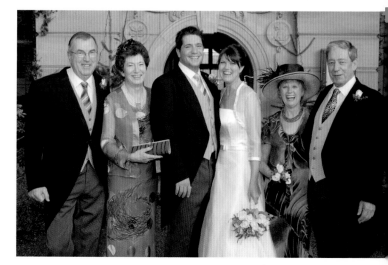

The finished image is a vast improvement – perfect for the wedding album!

hanging faces

ne of the most photographic common tasks you'll need
 perform is changing a face or a mouth because the
xpression is not right, or opening eyes in an image due
 a subject blinking. Both of these are easy to do, but try
 d start with a similar crop size otherwise you will have
 use the transform function (*Edit > Free Transform* or
 trl/Cmd+T) to change the image size before you start
 ny cloning. In this example, we could move the dad's
 xpression and face from one image to the other using the
 uto-Align Layer method described earlier. However, this
 chnique shows you another way and at the same time
 emonstrates how you would use the Clone Stamp Tool to
 one parts of one image onto another image.

**The father's smiling face will be cloned onto the picture
in which the girl is looking at the camera.**

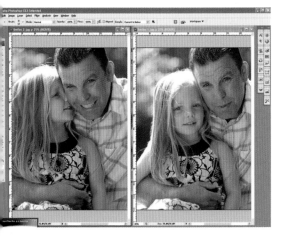

Open the two images side by side and choose the one you want to copy
 clone from. Select the Clone Stamp Tool (shortcut S). Alt+click to set the
 urce point for the clone.

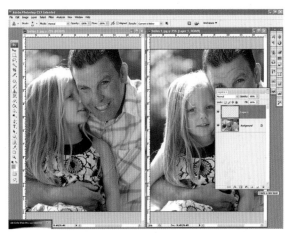

2 Select the other image and create a new layer in the Layers palette –
this is so that the clone can be moved or manipulated later.

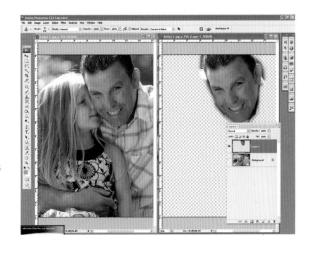

3 Now just paint near to where the clone needs
to be placed. Clone more than you need around
the area, as it is quicker to erase elements later.
I have switched my Background layer off to see
just the new clone layer.

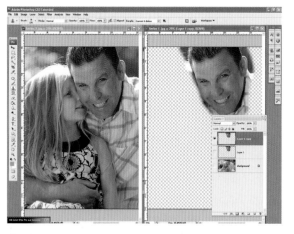

4 Duplicate the clone layer by dragging it onto the *Create a new layer* icon or pressing Ctrl+J on the keyboard, then switch the layer off by toggling its eye icon in the Layers palette. We will keep this layer as a backup in case we erase too much and need to recover some detail later on.

5 Switch on the Background layer and then lower the Opacity to around 60% to align the images. If the new cloned area is too small or too large, use the Free Transform Tool (*Edit > Free Transform* or Ctrl/Cmd+T) to transform it, holding down the Shift key to maintain the correct proportions. When the layers are accurately aligned, erase the parts you have cloned that you don't need, watching out for patterns and where people touch.

6 Before you flatten the image, switch the background layer on and off several times to check whether there are any stray bits of the clone left to be erased.

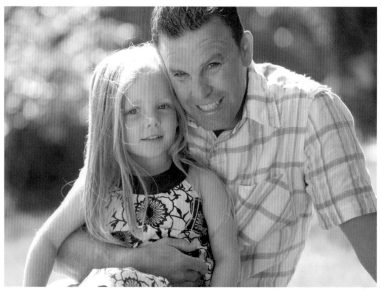

The finished image combines the best bits of the two original images.

Making a group montage with cutouts

This is one of my favourite creative processes in Photoshop. I call it multiplicity, and it involves combining multiple images of the same person in an image at different sizes. The effect is much easier to create if the images are all shot against the same (preferably white) background.

Create a new blank document by going to *File > New Document*. My document measures 20×16in (51×41cm) at 240 dpi.

2 Open your first image and cut it out. Use the Magic Wand Tool (W) to select the background, with a Feather to soften the edges slightly, and invert the selection with *Select > Inverse* so that the subject is selected and not the background.

3 Select the Move Tool (V) and drag the image from its source to the new montage document. Drag the image instead of copying and pasting it, as this uses less memory and won't slow down your system.

4 Close the original image and select another for the montage. Cut it out and drag it onto your montage. Repeat the procedure with several different images. If the canvas starts to look too full, enlarge the canvas by going to *Image > Canvas Size*. Select the centre square on the bottom row of the layout icon – this will add extra space each side of the original document.

5 Select the Move Tool (V) and check the *Auto-Select* box on the Tool Options Bar. This will automatically select the layer you click on, which is essential on a busy screen.

6 Each image can now be dragged around the canvas as desired. You can also drag the layer icons up and down in the Layers palette to change their order, or flip the images around by using *Edit > Transform > Flip Horizontal*.

The secret to a successful montage is to keeping the direction of the lighting looking similar and believable across all the images – as well as scaling the images, which I have done here with *Edit > Free Transform*.

The finished montage.

HIGH DYNAMIC RANGE

A High Dynamic Range (or HDR) image is one that incorporates both highlight and shadow detail that could not all be captured in-camera in a single frame. HDR images are created by blending identical images with different exposures, or combining RAW files that have had exposure corrections made to increase the level of detail in the highlight and shadow areas.

To create a High Dynamic Range image, first shoot an identical scene at a variety of exposures.

One f-stop underexposed

Correct exposure

One f-stop overexposed

Shooting for HDR

HDR blending can be used when you want to pull out every detail in an image – in a landscape, for example, where it is impossible to shoot one picture that shows detail in bright skies as well as shadow areas.

For the best results, use a tripod when shooting the scene and lock it off so there is no change in the scene except the different exposures. If you intend to use Photoshop's Merge to HDR feature, as described below, remember to change the shutter speed for bracketing and not the f-stop.

When you have composed the image and locked off the tripod, take meter readings for both the highlights and the shadows – let's say we have a reading of 1/125 second at f16 for the highlights and 1/15 second at f16 for the shadows.

Now take a variety of exposures, being careful not to adjust the focus or focal length – it's best to switch off any auto-focus facility. Take the first exposure at the highlight reading of 1/125 second at f16, then the midtone readings of 1/60 at f16 and 1/30 at f16, and finally 1/15 second at f16 for the shadow detail. These images will then be combined later in Photoshop to produce one image that shows as much or as little detail as needed.

Tip

If your camera has an Automatic Exposure Bracketing facility (AEB), this is the ideal time to use it. Half-stop exposures could also be taken for even more variety in detail, but make sure you choose the shutter speed to adjust and not the f-stop.

Use your camera's auto bracket function when shooting for HDR.

s you can see from the images below, when a simple HDR blend is applied in Photoshop, there is a greater degree of etail in both the highlight and shadow areas in the final image.

nderexposed

Correct exposure

verexposed

After HDR blending

HDR blending

Blending several exposures to make one perfect or near-perfect HDR image is simple in Photoshop. In this example, rather than taking multiple exposures, I duplicated the original RAW file and applied exposure corrections to the duplicates before blending all the images together.

1 Select the images to use for your HDR merge. If you have shot one RAW file, duplicate it twice and make adjustments to the two duplicates – one for highlight detail and one for shadow – giving you a correct exposure, an overexposed and an underexposed selection of files.

2 If you are working in Bridge, go to *Tools > Photoshop > Merge to HDR*. If you're working in Photoshop, go to *File > Automate > Merge to HDR* and then select the relevant files.

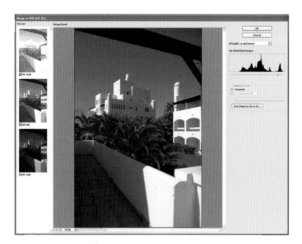

3 In the *Merge to HDR* window, save the file as 32 bits per channel and click *OK*.

4 With the HDR image open, select *Image > Adjustments > Exposure* to fine-tune the image. Adjust the *Exposure* and *Gamma* sliders until you achieve the desired result.

5 Finally, select *Image* > *Mode* > *8 Bits/Channel* to create the final file. Ensure *Exposure* and *Gamma* are selected in the *Method* box. Click *OK* and a new 8-bit file is created that is ready for printing.

he finished HDR file shows a far reater range of detail in both the ighlights and the shadows. This ould be impossible to achieve in single exposure.

Summary

■ What a chapter! If you are not excited about Photoshop now, you never will be. We covered some complex techniques, but remember – the more you practice these key skills, the simpler Photoshop will become. There is always more to learn in Photoshop, but there are numerous functions that most photographers will never need to use. The skills you need to get you started are covered in this book, and you will of course pick up many new ones as you go along. Use Photoshop regularly, and it soon becomes familiar.

■ Automation is the key to Photoshop, and any task that you perform often and is repetitive or mundane should be made into an Action. But it's vital that you name your Actions logically and keep them well organized, or you will waste valuable time searching for the right one.

■ Adding text to your images is fun, but it's easy to get carried away. The last thing you want is to spend a long time perfecting an image only to spoil it with ill-considered or inappropriate text, so keep it simple. Think carefully about which fonts you use, and don't use too many different fonts on the same image. Keep effects to a maximum of two or three per image, remembering to use the Color Picker to choose a matching colour from anywhere on the desktop. Text can become a wash by simply adjusting the opacity of the text layer.

■ Now you've done all this work, you'll want to know how best to present your images, either digitally or as prints. We'll cover that in Chapter 5.

Checklist

QUICK FIXES

❏ Lightening an Image

❏ Correcting Horizontals and Verticals

❏ Fixing Colour

ADDING TEXT

❏ Text Tool

❏ Text Effects

❏ Warped Text

❏ Layer Styles

❏ Type Mask Tool

WATERMARKS & COPYRIGHT

❏ Text Opacity

❏ Warp & Wash

❏ Custom Shape

❏ Layer Styles – Bevel & Emboss

PANORAMAS & MONTAGES

❏ Auto Align

❏ Auto Blend

ACTIONS

❏ Creating Sets

❏ Using Actions

PERFECT PORTRAITS

❏ Using the Channel Mixer

❏ Surface Blur

❏ Brightening Eyes

❏ Combining Two Shots into One

HIGH DYNAMIC RANGE

❏ Shooting for HDR

❏ HDR blending

Output

Last, but by no means least, this is the chapter where you learn how to show off your photography and manipulation skills by outputting your pictures to either print or the web. Whether you are printing your images yourself at home on an inkjet printer, sending them to a lab, or preparing your images for a web site or digital presentation, you need to prepare your pictures properly to maximize the quality and obtain the best possible results. Here's how.

■ CREATING SLIDESHOWS

■ MAKING PDFS

■ CREATING WEB PAGES 1

■ CREATING WEB PAGES 2

■ PRINTING FROM PHOTOSHOP

■ PRINTING CONTACT SHEETS

■ SUMMARY & CHECKLIST

CREATING SLIDESHOWS

Bridge has a great slideshow feature that makes highly effective presentations, and is very easy to use. However, you cannot export Bridge slideshows, so if you want to share a slideshow with friends, family or clients, you will have to either make a PDF slideshow in Photoshop (see pages 156-157) or use one of the many third-party programs that are available, such as Photodex Pro Show Gold.

Bridge slide shows

A Bridge slideshow in progress.

1 To play a slideshow in Bridge, first select the images you want to view as a slideshow. If it's everything shown in the Bridge window, just select the first slide and the program will grab everything else.

2 Press Ctrl/Cmd+L or select *View > Slideshow* from the main menu to start the slideshow. The slideshow will automatically display the images at the largest size that fits on your screen.

3 The slideshow will advance by itself. To pause it, press the Space Bar; press the Space Bar again to resume the show. To go to the next slide, use the Right or Down Arrow key, and to go back, use the Up or Left Arrow key. When all the images have been viewed, the slideshow will end – unless you have checked the *Repeat Slideshow* box in the *Slide Show Options* (see page 155). If you want to leave the slideshow mode at any time, press the Esc key.

Remember, if the image is clicked during playback it will jump to 100% magnification – this is great to see fine detail or a facial expression in a group, but all of the following slides will be viewed at the same zoom level until you click again.

Slideshow Options in Bridge

Open the Slideshow Options dialog in Bridge by pressing Shift+Cmd/Ctrl+L or going to *View > Slideshow Options* from the main menu. Here you will be presented with a number of choices, including *Slide Duration* and *Transition Options*, which determine the way one image changes to another. You can also check the *Repeat Slideshow* box, which keeps the show going until you stop it manually, and the *Zoom Back And Forth* box, which adds a zoom-and-pan motion effect to the slideshow (sometimes known as the Ken Burns effect).

If you are just using the slideshow to review your own images, rather than to present them to other people, set the *Slide Duration* and *Transition Options* to none, as this will allow you to work more quickly.

Most of the options are quite self-explanatory, so rather than stating the obvious, here are three recommended settings for different types of slideshow.

Slideshow for friends
Slide Duration: 2 seconds; *Transition*: Move In

Slideshow for clients
Zoom Back & Forth checked; *Slide Duration*: 5 seconds; *Transition*: Move In; *Caption*: Full

Public slideshow
Zoom Back & Forth checked; *Slide Duration*: 5 seconds; *Transition*: Random

Tip
Press H to open the Slideshow Options when you are in Slideshow mode, and again to hide them.

The Bridge Slideshow Options dialog box. Here, a Revolving Door transition has been chosen from the drop-down menu.

Adding music

Open a new window in Bridge (*File > New Window*) and navigate to the music files you want to play to accompany your slideshow. Select the tracks (individually by Ctrl/Cmd+clicking, or Ctrl/Cmd+A to select all) and they will start playing – if they don't, open the Preview window (*Window > Preview Panel*) and drag them in. Then return to your original window with your slideshow images ready to go and press Ctrl/Cmd+L to start the slideshow. It's not as slick as it should be, but it works!

Audio files can be loaded into Bridge and used to accompany your slideshow.

MAKING PDFS

As we saw on pages 154-155, Bridge can produce excellent slideshows but they cannot be exported or shared. But in Photoshop you have the ability to convert files to PDF, a widely supported format ideal for sharing. You can also make a series of files into a slide presentation or a document for distribution – perfect for emailing images to friends and clients.

PDF presentations

1 To make a PDF slideshow, go to *File > Automate > PDF Presentation*.

2 Add the images that you want to include. Select them by pressing the *Browse* button, or – if you already have the files open in Photoshop – by checking the *Add Open Files* box. Then click on the *Presentation* box in the *Output Options* portion of the PDF Presentation dialog.

3 In this dialog box you can also choose the information that you want to be visible as part of the slideshow – such as the filename and copyright information – and select how long each image is to be displayed on screen, as well as the background colour and transition effect.

Choosing a Transition effect from the drop-down box.

Selecting a Background colour.

Click *Save*, and choose a location where the PDF slideshow will be stored. When this is done, the ve *Adobe PDF* dialog box will appear, giving you some quality and security options.

5 Finally, click *Save PDF* and the automated presentation will start to build. Double-click on your PDF file in the location you saved it to and the presentation will start.

e *Adobe PDF Preset* menu gives **ou various quality options for your** **ideshow. If you intend to email your** **resentation, remember to select** **mallest *File Size*.**

The *Security* options enable you to set a password to open the presentation and restrict editing and printing.

If you set a password in the *Security* options, the recipient will see a dialog box like this when they attempt to open your presentation.

Multi-page PDF Documents

To make a straightforward PDF document of your images, rather than a deshow presentation, go to *File > Automate > PDF Presentation* and select e images to be inserted as before. Click on *Multi-Page Document* in the *F Presentation* dialog box.

Set the information you want visible, filename, copyright information d background colour as before. Then click *Save* and choose a location here the PDF document will be stored.

3 In the *Save Adobe PDF* dialog box, select the quality of printing you require – this should usually either be *Smallest File Size* for proofing or *High Quality Print* for printing. Use the security options if you are going to restrict printing, but you will need to remember the password.

4 Click *Save PDF* and the automated multi-page document will start to build. Doubel-click on your PDF file to open the document, as before.

PDF saved with the Smallest File Size quality setting.

At the High Quality Print setting, the image is much clearer and sharper – but the file size is also much bigger, so don't use this setting if you intend to email your PDF.

CREATING WEB PAGES 1

A website is essential for any serious photographer, allowing potential clients to view your work quickly. Photoshop enables you to build a variety of automated web galleries at the click of a button; these can then be uploaded to your own website or distributed on a CD.

1 To make a photo gallery website, go to *File > Automate > Web Photo Gallery*.

2 In the resulting *Web Photo Gallery* dialog box, first select the gallery style you would like from the drop-down *Styles* window. There are several styles to choose from – some are basic and some even include Flash technology – but this is just a matter of taste. A small preview of the chosen layout is shown on the right of the window. Then, in the *Source Images* section, select the folder of the images that you want to include in your web gallery, and the destination folder where the website will be stored – this cannot be in the same folder as the source folder.

3 In the *Options* box, click on the drop-down menu and select *Banner*. You can then enter your image information and contact details as well as the name of the site; the date is entered automatically.

Select the other options in the menu in turn. *Thumbnails* determines the thumbnail size in the contact layout, and *Custom Colors* sets the colours to be displayed on screen. *Large Images* sets the size of the full image when the user clicks on it on the website. Check the *Resize Images* button and choose a preset size from the adjacent drop-down menu, or a *Custom* size of your own. This setting has a profound effect on the website because if the image size is set too large, the user may need to scroll around the window to see the whole image.

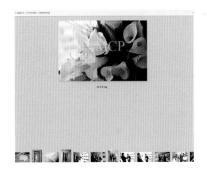

Resize Images set to 450 pixels (the Large preset).

Resize Images set to a Custom size of 600 pixels.

Set the *Security* options. If you have included copyright information in the Copyright field of your images' metadata, select *Copyright*, and the information will be displayed with your images on the website. You can make this appear as a wash over the images by altering the Opacity. If you have not included any copyright information in the files' metadata, select *Custom Text* from the content window and type in your text in the *Custom Text* box.

Finally, click OK and the gallery will start to build. This may take several minutes if there are a lot of images in the source folder, so when you're testing different gallery looks, it's a good idea not to include too many images. Use around 24 images to give you a good feel for the style and layout. When it has finished building your gallery, Photoshop will automatically launch an Explorer window where the site is stored. Open the gallery in your web browser to see how it looks.

Two different styles of web gallery created in Photoshop.

CREATING WEB PAGES 2

Even though the web galleries in CS3 are a little basic, Adobe has developed a new gallery building system called AMG, Adobe Media Gallery, which is a free update to Bridge. Original copies of CS3 did not come pre-loaded with AMG, so to check whether your version has it installed, go to *Window > Workspace*. If Adobe Media Gallery appears in the menu, you've already got it. If not, go to www.adobe.com and download the Bridge update (version 2.1 or higher), and then go to http://labs.adobe.com/wiki/index.php/Adobe_Media_Gallery to download AMG.

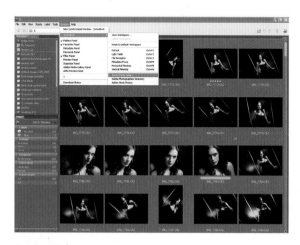

1 When you've checked you have the necessary software installed, open Bridge and go to *Window > Workspace > Adobe Media Gallery*.

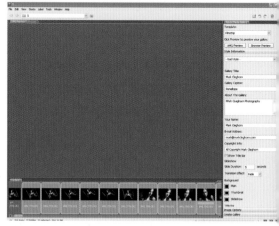

2 The workspace will enter a filmstrip mode. To save on desktop real estate, double-click the sidebar of the *Folders* palette to close it down. The images are now running along the bottom and the AMG option panel runs down the right-hand side.

3 Ctrl/Cmd+click or Shift+click to select the images you want to include in your gallery, then click the *AMG Preview* button at the top of the *AMG Template* panel.

4 Choose a template from the *Template* drop-down menu. There are several to choose from, but each time you change to a different template you will have to press the *AMG Preview* button again to update the preview screen.

In the *Style Information* panel you can customize your website, setting text, site and contact information, as well as the *Transition Effects* and *Slide Duration*. You can also customize the colours using the *Background* control, but try to exercise some restraint, as it doesn't take long to make a cool site look far too busy.

6 In the *Image Options* panel you have four options for both the Thumbnail and Preview images, which are Extra Large, Large, Medium and Small.

Two different web gallery styles constructed in Adobe Media Gallery.

7 Last of all is the *Create Gallery* panel, where the whole thing is either saved to disk or uploaded to your server. AMG web galleries are much more flexible than the Photoshop alternative, so it's well worth downloading the relevant software and experimenting with what it has to offer.

PRINTING FROM PHOTOSHOP

What you see is not necessarily what you get when it comes to printing, even if your screen is calibrated, because a printer will still give different results depending on its setup and the paper you print on. Check your settings carefully and print a test page to assess your output

Colours on your monitor are displayed by mixing red, green and blue (RGB), but on an inkjet printer the colours are created by mixing cyan, magenta, yellow and black (CMYK). That is why a perfect match is hard to achieve – the range, or gamut, of colour is different. The colours therefore have to be converted for the printer and the paper you're using.

Profiles

To get professional-looking results from your printer, you will have to do some basic housekeeping, especially when you change the type of paper you are using. Most inkjet paper manufacturers now provide free custom profiles to download for their papers. Installing these will ensure you get a better-looking result every time.

1 Go to the home page of the paper company you are going to use and look for ICC Printer Profiles or Colour Profiles. Then select the printer you are using.

2 Find the paper you are going to print on, and choose the ICC profile for your operating system. Save the download.

3 To install the profile, right-click on it and select *Install Profile*.

4 With the profile installed, launch Photoshop and open your finished image. You are now ready to print – or should I say almost ready. First you need to check the *Document Properties*.

Document Properties

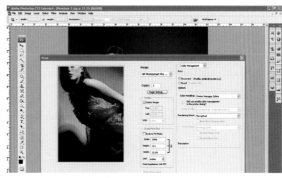

1 With your image open in Photoshop, go to *File > Print* or press Ctrl/Cmd+P on your keyboard.

2 In the *Print* window, click on *Page Setup*. This will open the *Document Properties* dialog box.

3 Select the *Print Quality* and the *Paper Type* from the drop-down menus. Select the paper size and click *OK*; this will take you back to the main *Print* window.

4 If you set up a custom paper, you may have to leave the dialog box by pressing *OK* and then go back in to select the new type of paper.

Colour management

In the Print dialog box there is also a drop-down menu called *Color Handling*. If you have installed the correct paper profile, choose *Photoshop Manages Colors* instead of *Printer Manages Colors*. This means that Photoshop will do the maths for the RGB-to-CMYK colour conversion. But remember to disable the colour management in the printer properties when using Photoshop to manage colour, or the results will not look as they should.

Soft Proofing

Even though your monitor should be displaying colour accurately if you have calibrated your screen, you can set up a function called soft proofing, which changes the look to suit the printer and paper you are using.

To do this, go to *View > Proof Set up > Custom*. In the dialog box, select the printer and paper to simulate, making sure you check the *Black Point Compensation* box and set the *Rendering Intent* to *Perceptual*. The image you see should be closer to the actual printed result. Save the settings for a quick recall on another image.

Ring Around

If you are having problems getting good colour results from your printer, you will have to resort to a ring around. This involves creating a colour-test page that shows your image's colour adjusted in several different ways. When you've printed it you can judge which looks best.

1 Choose an image with a good collection of natural skin and colour tones. Crop through the image to make it approximately 3×2in (7.6×5cm) high.

2 Now make a new document by going to *File > New*. Choose a regular paper size for your printer, eg A4, at the same resolution as the cropped image. Select the Rectangular Marquee tool (shortcut M) and drag a narrow box down the page. Reset the foreground and background colours by clicking the *Default Foreground and Background Colors* icon on the Tool Bar. Select the Gradient tool from the Tool Bar (shortcut B, underneath the Paint Bucket) and drag a line from the top of the box to the bottom to fill it with a neutral gradient. Drag the cropped image onto the new page with the gradient and rename its layer Normal.

3 Select the cropped image again and go to *Image > Adjustments > Variations*. Drag the slider down to the penultimate marker on the left. Then click on the *More Yellow* image and click *OK*. Drag this image onto the colour test page, and rename the layer 1 Yellow.

4 Reselect the cropped image again, open the History palette and step backwards to before the colour change. Go back to *Image > Adjustments > Variations* and double-click the original to reset the colour adjustment. Repeat the operation for all the colours, dragging each one onto your colour-test page.

5 Add text to the colour test page to indicate which image has had which adjustment applied and save the image. This method takes some time but you will be able to refer to the colour test page to accurately adjust your images to compensate for any paper or printer errors. When you find the adjustment that works best, an action can be made to apply these changes before printing.

A finished colour-test page showing the same image with various different colour adjustments applied.

PRINTING CONTACT SHEETS

Photoshop has an automated contact sheet maker that will reduce a quantity of images down in size to fit any page and add the filenames at the same time, making multiple pages automatically if necessary to include all the images in a folder. To use it, go to *File* > *Automate* > *Contact Sheet II*. A dialog box will open with several options to set.

1 In the *Source Images* section, first select the source folder of images you want to use by selecting it from the *Use* box or using the *Browse* button. The *Include All Subfolders* checkbox, when checked, will include images contained in subfolders in the contact sheet.

2 In the *Document* section, first select the unit of measurement – inches, centimetres or pixels. Then set the overall document size needed for the contact sheet – in this case, 16×12 ins (41× 30cm) – and the resolution. Check or uncheck the *Flatten all Layers* box depending on whether you want to keep each of the images separate on the contact sheet and not as a single layer. This is checked by default and I would recommend you keep to that. The *Mode* should usually be set to *RGB Color*, but if you only need a black-and-white contact sheet, switch it to *Grayscale* to make the file size smaller.

3 The *Thumbnails* section determines how many images are on each sheet (this is also shown by the page icon on the right) as well as their size, which is based on the quantity of images, and the page size. In the *Place* menu, choose whether your images are to flow across or down first. I usually go across first. Choose the number of rows and columns you require in the *Columns* and *Rows* boxes. The *Rotate For Best Fit* options allows better spacing on the sheet, as it will rotate a horizontal or vertical image to fit the grid – you can fit more images on a page, but you will have to turn the page around to look at the rotated images.

4 Checking *Use Filename As Caption* will display the filename next to each image on the sheet, in the font and size you specify in the boxes below. Keep the font simple so you can easily read the text, and small enough to not dominate the page layout – large text will mean your images are smaller, as it takes up space on the page.

5 When you've finished, click *OK* and let Photoshop do its stuff.

6 The contact sheet will consist of two layers, the Background and the image layer. You can customize the look of your contact sheet in a variety of ways by changing to the Background layer – perhaps adding a colour to the background or adding a copyright wash over the images. Some examples are shown on page 167.

Tip
If you are using Bridge, you can make the same contact sheets by going to *Tools* > *Photoshop* > *Contact Sheet II*.

contact sheet with a plain colour added to the
background layer.

Try adding noise (*Filter > Noise > Add Noise*) to the
background to break up the solid colour.

ou can also add copyright text with a wash effect (see
ages 126-127) and a Bevel & Emboss effect if you wish.

Use the Gradient tool to add interest to a solid colour.
Choose your gradient style from the Tool Options Bar.

ry duplicating the image layer and adding motion blur
Filter > Blur > Motion Blur) to the bottom image layer.

In this example, the images have been rotated for best fit
(see step 3 on page 166).

Summary

■ So that's it – all you need to know about Photoshop to start producing really creative images, as well as correcting and manipulating your photographs quickly. Outputting your images is of course just as important as creating them in the first place – why go to all that effort if no one else will ever see them? – so it's important to pay close attention to this stage of the process and ensure you produce the best-quality prints and the most effective presentations.

■ In the course of the chapter we also used many of the skills that you learned earlier in the book, and you may have found that you could remember them without referring back – so your key Photoshop skills are already improving after just one weekend.

■ It doesn't end there, though – you will probably want to keep coming back to this book time and time again. Each time you do, you will be that little bit more confident and you'll be able to skip a lot of the explanation and get straight to the task at hand. Every time you use Photoshop, you'll discover for yourself one more little thing that it can do, and before you know it you'll be Photoshopping like a pro.

Checklist

SLIDESHOWS

❏ Making a Slideshow in Bridge

❏ Adding music to a slide show

PDFS

❏ Making a PDF Presentation

❏ Making a Multi-Page PDF
 Document

WEB GALLERIES

❏ Using Adobe Web Gallery

❏ Setting up and choosing a style

❏ Adobe Media Gallery

PRINTING

❏ ICC Printer Profiles

❏ Setting up to Print

❏ Ring Around Colour Tests

CONTACT SHEETS

❏ Adobe Automated Contact Sheet II

❏ Adding backgrounds

Adjustment layer A special layer that is specifically designed to apply effects to the layers below it in Photoshop's Layers palette. These effects do not permanently change the pixels in an image and can be therefore be removed or altered at any time.

Aliasing The appearance of jagged pixel edges that can be seen within any curves or lines of the image at or around 45 degrees. Anti-aliasing is the process used in Photoshop and other image software that helps to soften the edges of the image to reduce the effect of aliasing.

Algorithm A mathematical equation that gives a solution for a particular problem. In relation to photographic imaging, this relates to a set code that will define how the values of particular pixels will alter in an image.

Alpha channel An image channel that is used to store transparency information that can be used alongside the standard colour channels – for example, when making masks.

Artefacts Imperfections in an image that are generally caused by image manipulation, inherent flaws in the capture process or by computer errors which may manifest digitally themselves in the image. Noise is one example of an image artefact.

Aspect ratio The ratio of the width of an image to its height.

Background image The base image which lies beneath any additional layers that have been applied to the image. The fundamental building block of any Photoshop imaging work.

Batch processing The application of a series of commands to multiple files at the same time.

Bicubic interpolation A method of interpolation whereby new pixel data is created by calculations involving the value of the nearest eight pixels. This method is superior to other forms of interpolation, such as bilinear interpolation and nearest neighbour.

Bilinear interpolation Similar to bicubic interpolation, but only four of the nearest neighbouring pixels are used to create new pixels, giving softer results than bicubic interpolation.

Bit A unit of information that can only have one of either two values: 1 or 0.

Blending mode Blending modes control the way in which one image layer interacts with the layers beneath it in Photoshop's Layers palette. The blending mode is set in the pop-up menu at the top of the Layers palette.

Brightness The lightness or darkness of a colour, measured from black (0%) to white (100%).

Byte The standard unit for digital storage, a byte is made up of 8 bits and has a value between 0 and 255. 1024 bytes is equal to 1 kilobyte (KB) and 1024 kilobytes is equal to 1 megabyte (MB).

Calibration Matching the output of a device to an accepted standard – for example, to create desired colour reproduction.

CCD Charge-Coupled Device: a semiconductor that measures light. Commonly used in digital cameras.

Channel Information within an image that falls into a group – for example, a band of colour such as red or blue. Channels can be manipulated individually in Photoshop.

CMOS Complementary Metal-Oxide Semiconductor: an alternative to the CCD sensor, widely used in cameras and computers.

Colour gamut The range of colours able to be reproduced by a device and visible to the naked eye. Also the range of colours available within a particular ICC colour profile.

Colour mode The way in which an image represents the colours and tones that it contains. Not to be confused with ICC colour profiles, colour modes include RGB, CMYK and greyscale.

Compression A process in which a digital file is made smaller to save

…rage space. Compression comes in …o types: lossy, in which the image …ality is degraded; and lossless, in …hich the original quality of the file …kept intact.

…oning The process of duplicating …els from one part of an image and …acing them onto another part.

…epth of field The amount of the …age that falls in sharp focus from …reground to background.

…alog box An on-screen window …at allows you to make alterations …the image and often preview those …terations before finalizing the effect …command.

…pi Dots per inch, for measuring …e resolution of a scanner, digital …e or printer.

…river A piece of software designed …control and run an external device …om the computer such as a printer …scanner.

…uotone A greyscale image that has …e addition of another colour which is …ot black.

…ynamic range The range of different …rightness levels that can be recorded by …digital sensor.

…dge sharpening An image-…anipulation process performed to …roduce higher-contrast edges.

Embedded data Data that is tagged onto a file – for example, ICC colour profiles and EXIF data.

Exposure The process of allowing light to reach a sensitive medium, such as film or a digital-camera sensor.

Feather A way of softening the transition from one effect into another and blurring the boundary lines between them. Very useful for making image selections appear more natural when copied into another image.

File format The format in which a digital file is stored. The format of a file will determine its flexibility and which programs can read it.

Filter Filters offer a way of applying an alteration to the whole or selected parts of the image.

Firewire Serial bus technology similar to USB that allows the transfer of data from one medium to another, such as from a scanner to a computer.

Gaussian blur A filter in Photoshop that is designed to soften and blur the image.

Greyscale A monochrome colour mode based on 256 tones, starting from white and going through a range of grey tones until it reaches black.

Histogram A graph representing the spread of pixel tones in an image.

History Photoshop's ability to display and return to a previous state that the image was in at any point during the manipulation process.

Hue The colour of light, as distinct from its saturation and luminosity.

ICC Colour Profile International Colour Consortium Profile: a named colour gamut that harnesses various characteristics.

Interpolation A method of increasing resolution by inserting new pixels into the image, based on calculations from existing pixels.

Inverse Reversing a selection so that all the pixels that were outside the selected area become selected, while those inside it are deselected.

JPEG A file format developed by the Joint Photographic Experts Group, featuring built-in lossy compression.

Keyboard shortcut Designated keys in Photoshop to run commands without the use of the mouse.

Lasso Tool Photoshop tool used to select parts of an image.

Layer Key Photoshop feature used to create composite images. Multiple layers may be created in a single image, with different effects applied to each one. They are like virtual sheets of acetate sitting on top of the image.

Layer opacity The opacity or transparency of each image layer. As the opacity is changed, the layers beneath become more or less visible.

LCD Liquid Crystal Display: most digital cameras and laptop computers, and many desktop computers, have flat LCD screens.

LZW compression Lempel-Ziv Welch: a form of lossless compression which is commonly applied to TIFF files.

Megapixel (MP) One million pixels, multiples of which are commonly used to denote the resolution of digital cameras' sensors.

Magic Wand Tool A tool which allows you to select similar groups of pixels based on their colour tone. The Tolerance can be changed to choose a wider or narrower selection of pixels.

Mask A technique which allows the user to mask off areas which will be excluded from the various manipulations applied to the image.

Monochrome An image made up solely of various tones of grey, or any other single colour.

Nearest neighbour An interpolation method where neighbouring pixels are used to create new data to increase the image size of a file. Generally used for line drawings and largely unsuitable for interpolating photographs.

Noise The digital equivalent of film grain, noise represents a distortion in original iage data that is often caused by a high ISO setting and poor exposure or over-manipulation of images.

Opacity The transparency of an effect that has been applied to an image, or the transparency of one layer that is placed over another, this is controlled by the Opacity slider in the Layers palette.

Pixel Picture element: the smallest constituent part of a digital image.

Pixelation The visibility of individual pixel edges within an image, often caused by excessive enlargement.

ppi Pixels per inch: a meaure of resolution; the number of points that are seen by a device by the linear inch.

Quick Mask A Photoshop feature that enables masks to be created quickly and easily. In Quick Mask mode, areas of an image can be selected or deselected using a simple painting technique.

RAW A generic term for the many proprietary file formats that are produced by different manufacturers' digital cameras, which retain flexibility in some shooting parameters.

Resolution The higher the resolution of an image, the more pixels it contains. A higher resolution provides greater image detail and results in a clearer and more defined image.

RGB A colour mode where all the colours within an image are made up of red, green and blue. RGB is the most common colour mode used in digital cameras, scanners and bitmap-based programs such as Photoshop.

Resampling Changing an image's resolution by either removing pixel information and thus lowering the resolution, or by adding pixels via interpolation, thus increasing the resolution of an image.

Selection An area of an image which i defined by a border created using one o the selection tools in Photoshop.

Smart Filter A Photoshop filter that, just like an Adjustment layer, does not permanently affect the pixels to which it is applied, so the effect can be removed or adjusted at any time.

Thumbnail A low-resolution preview image of a larger image file.

TIFF Tagged Image File Format: a lossless image format widely used by professionals.

USM Unsharp Mask: an image-sharpening process carried out by Photoshop's Unsharp Mask filter.

White balance A setting used in digital cameras to compensate for colour casts produced by different form of lighting. With RAW files, the white balance can be adjusted after shooting.

USEFUL WEBSITES

Adobe
http://www.adobe.com

Lexar (memory cards and accessories)
http://www.lexar.com

Bowens Lighting
http://www.bowens.co.uk/

Loxley Colour Labs (printing services)
http://www.loxleycolour.com

Calumet Photo (photographic products)
http://www.calumetphoto.co.uk

Nik Filters (Photoshop plug-ins)
http://www.niksoftware.com

Canon (cameras)
http://www.canon.co.uk

Nikon (cameras)
http://www.nikon.com

Flaghead Photographic (accessories)
http://www.flaghead.co.uk

Pro Show Producer (slideshow software)
http://www.photodex.com

On One Software (Photoshop plug-ins)
http://www.ononesoftware.com

Quantum (flash equipment)
http://www.qtm.com

Lastolite (lighting accessories)
http://www.lastolite.com

Sekonic (light meters)
http://www.sekonic.com

ABOUT THE AUTHOR

Mark Cleghorn is one of the foremost professional wedding and portrait photographers practising today. He runs his own successful studio and gives lectures and seminars on a wide variety of photographic topics.

Mark was one of the first photographers in his field to fully embrace digital technology in the late 1990s, and his digital workflow methods have been adopted by thousands of photographers.

He is one of the few photographers in the world to be awarded a Fellowship by four of the UK's major photographic organizations, and has won a host of accolades, including the SWPP's Digital Photographer of the Year Award, the MPA's National Avant-Garde Wedding Photographer and 17 Kodak European Gold Awards. Mark has written several books on portrait and wedding photography, lighting and Photoshop.

INDEX

A

Actions 14, 24, 134-7, 150
adding text 122-3
adjustment layers 57, 89, 170
Adobe Camera RAW 16, 44-51, 110
Adobe Media Gallery (AMG) 160-61
Adobe RGB 21
algorithm 170
aliasing 170
alpha channel 170
animated GIF files 16
artefacts 170
aspect ratio 170
audio files 155
Auto-Align layers 142-3
Auto Levels option 57
automatic colour setting 18
Automatic Exposure Bracketing 146
automation 150

B

background image 170
Background Layer 84
batch processing 170
Bevel and Emboss effect 167
black-and-white conversion 85,
 104-109, 136, 137
Black and White feature 106
Blacks slider 47
Blank layer 87
blemishes 64-5, 138, 141
Blending modes 86, 170
Blue Filter 106, 108
Bridge 10-11, 15, 36-7
 AMG 160
 contact sheets 166
 panoramas 128-9
 slideshows 15, 154-5
 using 38-43
 window 37
brightness 170
Brightness slider 47
Brushes 25
Burn tool 59
Button view 134

C

calibration 18-20, 170
camera colour management 21
Channel Mixer 104, 105
Channels 25, 170
chromatic aberration 98
Clarity slider 47
Clone Stamp tool 22, 66-7, 143-4
cloning 87, 171
CMYK 20, 21
Color Handling 163
Color Picker 23, 150
Color slider 48
colour 162
 adjustments 60-63, 121
 balance 18, 45, 63
 calibration 18-20
 changing 121
 depth 50
 gamut 170
 management 21, 163
 mode 170
 space 21, 50
colour-test page 164, 165
combining images 142-4
compression 170, 172
contact sheets 166-7
contrast, adjusting 56-7
Contrast slider 47
copying 87
copyright 126-7, 158, 167
crop to size 72-3
Crop tool 22, 24, 70
cropping 31, 70-73
custom balance 18
custom settings 107

D

deleting image files 42
detail 141, 146-7, 149
Device Central 17
dialog box 171
Diffuse Glow 101, 102
Digital Asset Management (DAM)
 26
Dissolve 133
DNG (Digital Negative) format 35

Dodge and Burn tools 22, 59
Dodge Tool 58
dodging and burning 58-9
dpi (dots per inch) 171
dragging layers 87
driver 171
drop shadow 88, 124, 126
Dry Brush filter 85, 101, 102
duotone 112, 171
Duplicate layer 84
dust 65
dynamic range 171

E

edge sharpening 171
Edit menu 26
Elements 12
embedded data 171
Eraser 22
eraser technique 141
Expodisc 18, 19
exposure 58-9, 80, 146, 171
Exposure slider 46
Extras menu 33
Eyedropper tool 22-3
eyes 64, 140

F

F- (function) keys 134
faces 142
feather 133, 171
feathered selections 90
file formats 34-5, 171
File menu 26
Fill Light slider 47
filter effects 100-103
Filter menu 27, 100
filters 171
flash camera setting 18
flattening image 35, 87, 139
Foreground and Background colour
 23
Forward Warp Tool 69
Front Image 75

aussian Blur 97, 102, 139, 171
eneral sharpening 77
enuine Fractal 75
IF (Graphics Interchange Format)
 35
radient layer 114
radient tool 167
reen Filter 106, 108
rey card 18
reyscale 49, 104, 110, 171
rids 32
roup montage 145
roup shots 142-5
uides 32

and tool 22
DR (High Dynamic Range) images
 146-9
ealing brush 22, 65
elp menu 28
igh Contrast Blue Filter 106, 108
igh-contrast effect 85
igh Contrast Red Filter 107, 109
igh Quality Print 157
ighlights 110, 146, 149
istogram 25, 171
istory 24, 171
orizontal correction 120
orizontal Filmstrip 36
orizontal Type Mask tool 125
orizontal Type tool
ISL/Grayscale 49
ue 62, 171

CC profiles 20, 162, 171
mage libraries 13
mage management 36
mage menu 26
mage-on-image montages 130, 132
mage quality 73, 75
mage Ready 17
mporting images 38
nfrared filter 107, 109
nkjet printers 162
nterpolation 74, 80, 170, 171, 172
nverse 171

J
JPEG 35, 50, 171

K
keyboard shortcuts 7, 22, 32, 33, 80,
 134-5, 171

L
labelling 39
landscapes 114
 black and white 106
 HDR images 146
 panoramic 128-9
Lasso tool 92, 171
Lastolite Ezybalance 18, 19
Layer Edges 31
Layer Mask Mode 95
Layer Styles 88, 124
Layers 14, 25, 27, 84-9, 116, 171
Lens Correction Filter 96, 98-9, 120
Lens Distortion 98
Lens Flare 103
Levels 56-7
lightening 120
lighting effects 114
Lightroom 13
Liquify Filter 68-9
luminance slider 48
Luminosity mode 86
LZW compression 172

M
Magic Wand tool 93, 121, 145, 172
Marquee tool 90, 97, 133
masks 94-5, 172
Maximum Black Filter 107, 108
Maximum Sharpening 79
Maximum White Filter 107, 108
menus 26-8
Merge to HDR 146-9
metadata 13, 15, 158
Metadata Focus 37
Moderate Sharpening 78
monitor 162
 colour calibration 20
monochrome 104, 172
montage 130-33, 145
Motion Blur 102, 125, 167
multi-page PDF documents 157
multiple images 145

Multiplicity 145
Multiply mode 86
music 155

N
Navigator 25
Neutral Density Filter 107, 109
Nik filters 103
noise 167, 172
Noise filter 103
Noise Reduction 48
Noiseware Pro 49
non-destructive layer 89
Normal mode 120, 86

O
opacity 85, 86, 139, 140, 172
organizing images 15
Outer Glow option 124

P
page layout style 130
panoramas 128-9
passwords 157
pasting 87
Patch tool 65, 138, 141
PDF slideshows 154, 156-7
perspective correction 99, 120
photo album layouts 132
Photo Filter 115
photo gallery website 158
Photodex Pro Show Gold 154
Photomerge 128-9
Photoshop
 colour management 21
 components 14-15
 Elements 12
 history 10
 Lightroom 13
 panoramas 129
 presets 113
 web galleries 158
picture ratio 75
pixelation 172
plug-in filters 103
portraits
 black and white 108-109
 improving 138-41
 sharpening 78
 vignettes 96-7

ppi (pixels per inch) 172
presets 113
Preview window 36
printer colour calibration 20
printing 157, 162-7
profiles 162
proofing 157
PSD format 35, 47, 87

Q

quick fixes 120-21
Quick Mask Mode 94, 172
Quick Selection Tool 92

R

Radial Gradients 115
RAW format 10-11, 15, 16, 18, 34, 172
 and black and white 109
 HDR images 146, 148
Recovery slider 47
Red Eye Tool 64
Red Filter 107, 108
Refine Edges 91
renaming image files 43
Repeat Slideshow option 154, 155
resampling 172
resizing 75, 80
resolution 51, 72-3, 171, 172
retouching 64-7, 80, 138, 142
 advanced 68-9
RGB 172
ring around 164-5
Rotate for Best Fit option 166, 167
rotating images 71, 166
Ruler Tool 31, 71, 72
Rulers 30

S

saturation 62
Saturation slider 47
Save for Web & Devices 17
scrapbook style 130
Screen mode 86
Security option 157, 158

Select 27
selecting a section of an image 90
selecting layers 87
selection 116, 172
Sets of Actions 135
shadows 110, 146, 149
Shape Tool 127
sharpening 48, 76
size of file 51
sky 114, 121
Slide Duration option 155
slideshow mode 40-41
slideshows 15, 154-5, 156-7
slimming subjects 68-9
Smallest File Size 157
Smart Filter 172
Smart Guides 32, 130
Snap 33
soft edges 133
soft-focus vignette 97
soft proofing 164
soft subjects 77
Softened Focus 138
sorting 39
splatter effect 133
split toning 49, 110-11
Spot Healing Brush 65
Spyder 20
sRGB 21
Step by Step 136
stitching images 128-9
stroke line 88, 131
Stroke line Action 136
Surface Blur filter 141
Swatches 25

T

text 122-5, 150
text effects 124-5
Text layer 88
thumbnail 172
TIFF (Tagged Image File Format) 34,
 50, 172
Tonal Curve 48

Tool Bar 22-3
Tool Options Bar 24
Tool Palettes 24
transform function 142
Transition option 155
tritone 113
Type Tool 122-3

U

'Ugly' channel 138
Unsharp Mask (USM) 76, 172
 settings 77

V

Variations 60-61
vertical correction 99, 120
Vertical Perspective slider 99
Vibrance slider 47
View menu 28
vignette 96

W

Wacom graphics tablet and pen 58,
 141
warp effect 124, 127
wash effect 127, 167
watermark 126-7
web galleries 13, 14, 16, 126
web page creation 158-61
Web Photo Gallery 158
Web Sharpening 79
websites 158
white balance 13, 45, 172
Window menu 28
workflow 80
workspaces 29

Y

Yellow Filter 107, 109

Z

Zoom Back and Forth option 155
Zoom tool 22-3

To request a full catalogue of Photographers' Institute Press titles, please contact:
GMC Publications, Castle Place, 166 High Street, Lewes, East Sussex BN7 1XN, United Kingdom
Tel: 01273 488005 Fax: 01273 402866
www.pipress.com